Wherever He Leads Me

THE GREG OLSEN COLLECTION

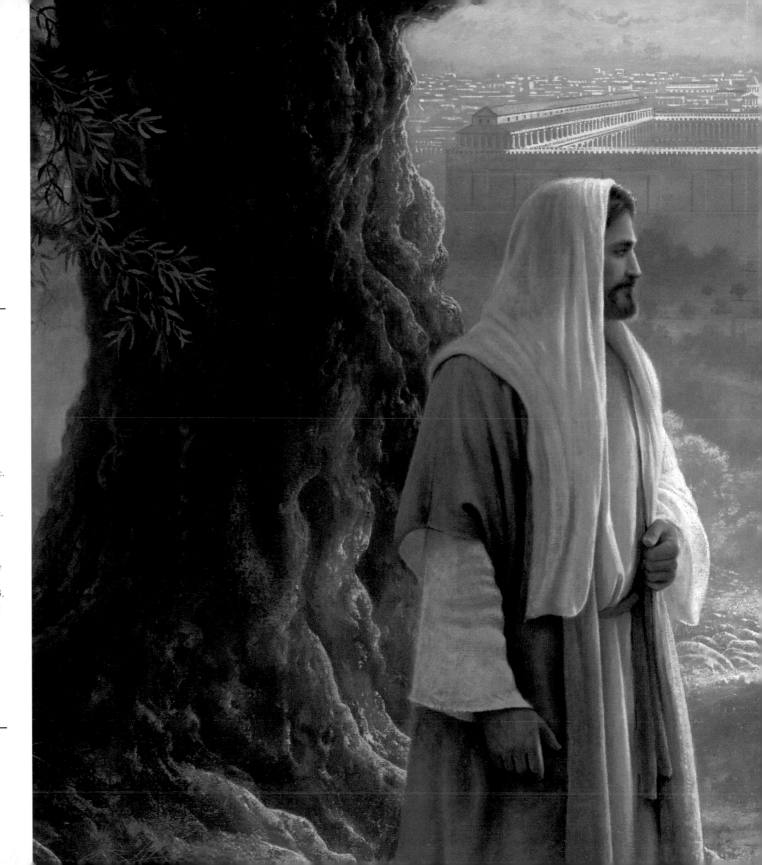

Cover painting, *Wherever He Leads Me* © Greg Olsen
Cover design copyrighted 2002 by Covenant Communications, Inc.
Cover and book design by Jessica A. Warner.

Published by Covenant Communications, Inc.
American Fork, Utah

Printed in China
First Printing: October 2002

09 08 07 06 05 04 03 02 10 9 8 7 6 5 4 3 2 1

ISBN 1-59156-099-3

Wherever He Leads Me

THE GREG OLSEN COLLECTION

Covenant Communications, Inc.

Covenant

Introduction

I was born September 25, 1958, in Idaho Falls, Idaho, and grew up in the nearby farming community of Iona. I can't remember a time when I didn't enjoy drawing. One of my first drawings I recall was on a big piece of butcher paper. It was an aerial view of my grandparent's farm—we called it "The Ranch," even though it was only 40 acres. I remember drawing each individual bale of hay in the field, and there must have been hundreds of them! I found plenty of things to draw around home, from the animals to the mountain scenery not far away. Our family spent a lot of time outdoors—camping, fishing, backpacking, driving cows, and herding sheep. These things instilled in me a love for nature and for the down-to-earth people around me. Art just seemed to be my way of expressing that love.

I was blessed with very supportive parents who encouraged me and provided opportunities for me to study and practice my passion. They were also tolerant. The very first artistic commission I received was as a young teenager. I was hired to paint a large sign for a local grocery store. It was wintertime and too cold to paint in the garage, so my parents let me set up a workshop in my bedroom. I promptly spilled two quarts of black and orange enamel paint all over my bedroom carpet. Amazingly, they still encouraged me.

I have also been blessed with teachers who have inspired me, befriended me, and changed my life as a result of their influence. On one occasion during a critique in a college art class, my professor held my painting up in front of the class and shouted out, "Whose is this?" I raised my hand from the back of the room and then heard the professor say in disgust, "Olsen, this is so bad, I'm not even going to talk about it." He then tossed it like a frisbee. It flew over my head and landed on the floor—I never picked it up! I'm grateful he was honest that day because it really was a terrible piece. It had been a last-minute, late-night, halfhearted effort, and he knew I could do better—and so did I! That day I laughingly told myself, "Next time, Greg, if you're going to do a terrible piece of art—at least spend a little more time on it!"

The life of an artist can be difficult. I discovered that fact as I left school and eventually began a career as a fine artist. Sales from my first art show barely covered the cost of refreshments and invitations. The struggles of the ensuing years taught me many things, and I wouldn't trade those years for anything. The greatest blessing to me has been my supportive wife, Sydnie. Only once during our marriage did she ever waver. Our home was near foreclosure, paintings were not selling, and there was not a commission in sight. She came to me and asked if perhaps I ought to consider

getting a "real job!" I had to concede she was right. We picked up a newspaper and started going through the Want Ads, looking for any jobs I was remotely qualified for. We soon realized I wasn't qualified to do anything else that would bring home much more than minimum wage. We laughed, and Sydnie sent me to the studio to get back to work! Somehow the Lord provided and we weathered those storms.

Over the years, doors of opportunity have been opened by mentors, patrons, and publishers, all of whom have become my friends. They have made it possible for me to pursue my passion. I'm so grateful to be able to do something I love. By working at home I have been able to be near those I love most—my wife and six children. They bring me the greatest happiness in life.

My philosophy on art is quite simple. "I appreciate the beauty of art and the way it makes me feel. I hope that people will be happy and uplifted when they see this work. I hope some of the images will help bring them peace and comfort. I believe that most of us have some kind of spiritual belief and we want to embrace those values. I like to think that my paintings might remind people of where they can find their strength and comfort, and help reaffirm what is really important in their lives.

Kreg K. Olsen

I like to think that my paintings . . . remind people of where they can find their strength and comfort . . .

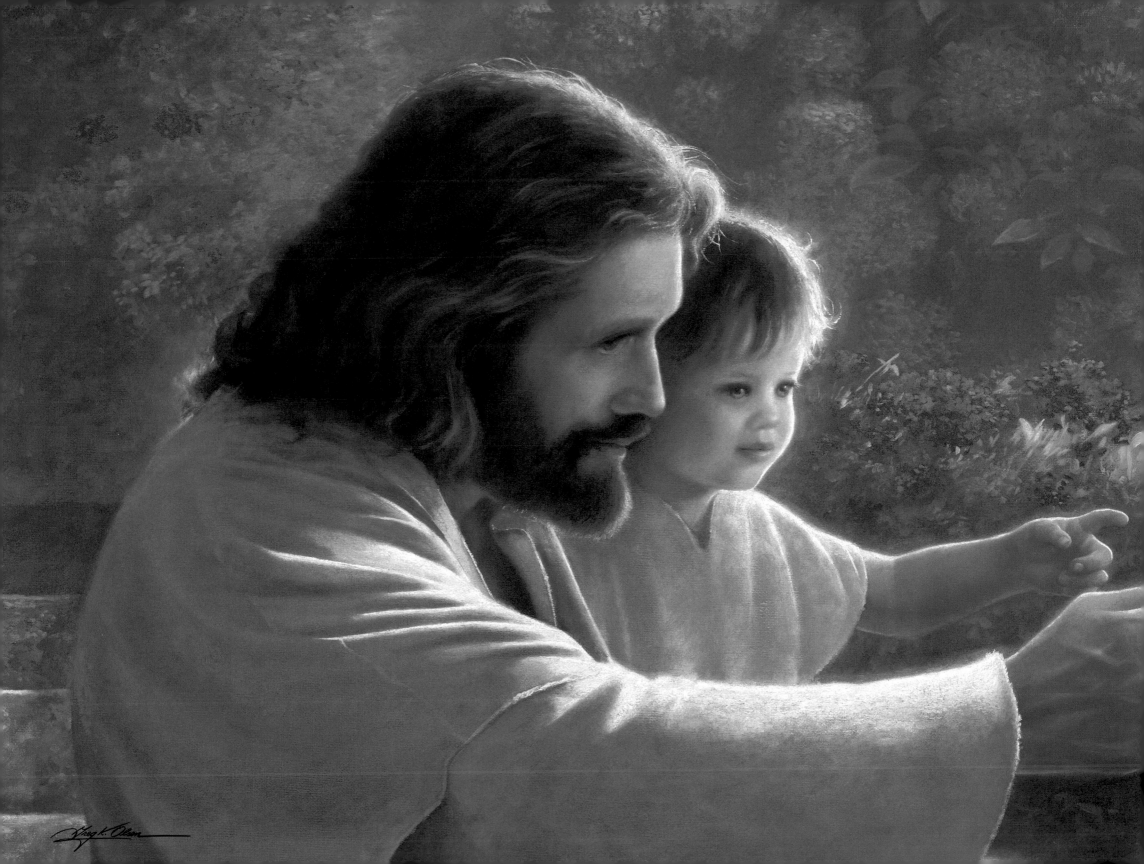

Precious In His Sight

Under His watchful eye, a tiny sprout grows to a lovely, fragrant flower, the drab cocoon brings forth the beautiful butterfly, and the Babe in the lowly manger becomes the Prince of Peace! These miracles bring wonderment and awe to our hearts, warming our souls like rays of sun on a spring morning, reminding us of an eternal truth—that all things are precious in His sight.

— GREG OLSEN —

Forever and Ever

Surrounded by His enduring love, we are warm, safe, and secure. That reassuring calm comes not by a spoken word or by gazing with our eyes upon His strong arms. It comes from the embrace which our heart feels and through the tender senses of our spirit. All around us we have the physical wonders and beauties of nature that bear the signature of their Creator and remind us of His enduring love. Although His presence is unseen by our eyes, His unending love is felt in our hearts.

— GREG OLSEN —

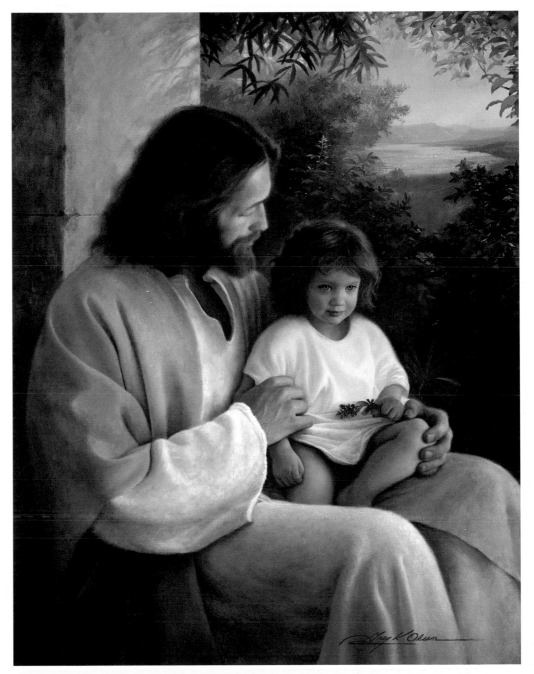

3

OPPOSITE: PRECIOUS IN HIS SIGHT. ABOVE: FOREVER AND EVER.

Melodies Remembered

Loving moments, like family heirlooms, are precious keepsakes and memories that intertwine to become the melody of our lives. We keep near us treasured tokens of cherished days that pass all too quickly. Cedar-lined chests hold souvenir dolls and dresses, mementos that bring back to life the wonder of toddlers talking to themselves in a world of their own, of little arms that hug tightly and of lips that unashamedly offer kisses. The hands of time move like a magic wand and our young cherubs soon bloom into more mature and gracious beauties, but nothing melts the heart quite like the face of an innocent child. These are moments we memorize and replay in our minds like an old favorite tune, and we can't help but smile once again.

— GREG OLSEN —

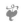

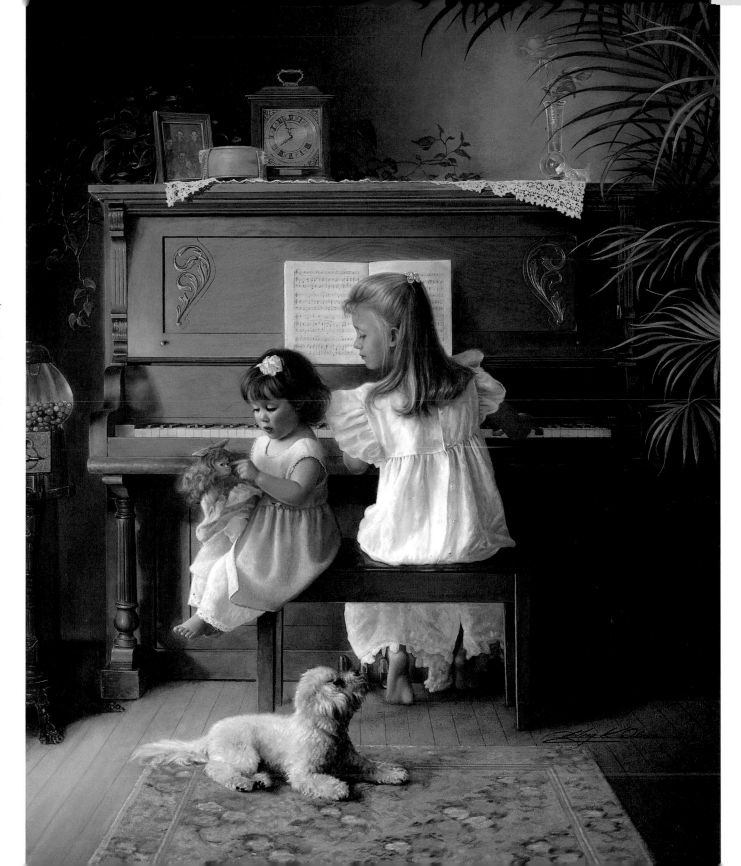

Little Boy Blue

The hidden price of artistic talent is practice. The seemingly unexciting exercises performed over and over again will later pay dividends in the form of proficiency, dexterity, skill, and the hope of attaining perfection.

Michelangelo said, "Trifles make perfection, and perfection is no trifle." Equipped with well-honed skills, we can be fit instruments through which inspiration and even genius can flow.

— GREG OLSEN —

Once Upon A Time

Turn back the hands of time to days lived happily ever after, when fairy-tale friends jumped from picture books into our rooms. They shared their stories with youngsters, bathed and ready for bed, dressed in flannel pajamas. They danced and played before our eyes, and their performance left us with vivid memories that are treasured long after time has marched us far from childhood. There's a magical world in that book on the shelf, and turning its pages can turn back the clock to a wonderful "once upon a time!"

— GREG OLSEN —

ABOVE: ONCE UPON A TIME
RIGHT: TRAVELING BY BOOK
OPPOSITE: AIRSHIP ADVENTURES

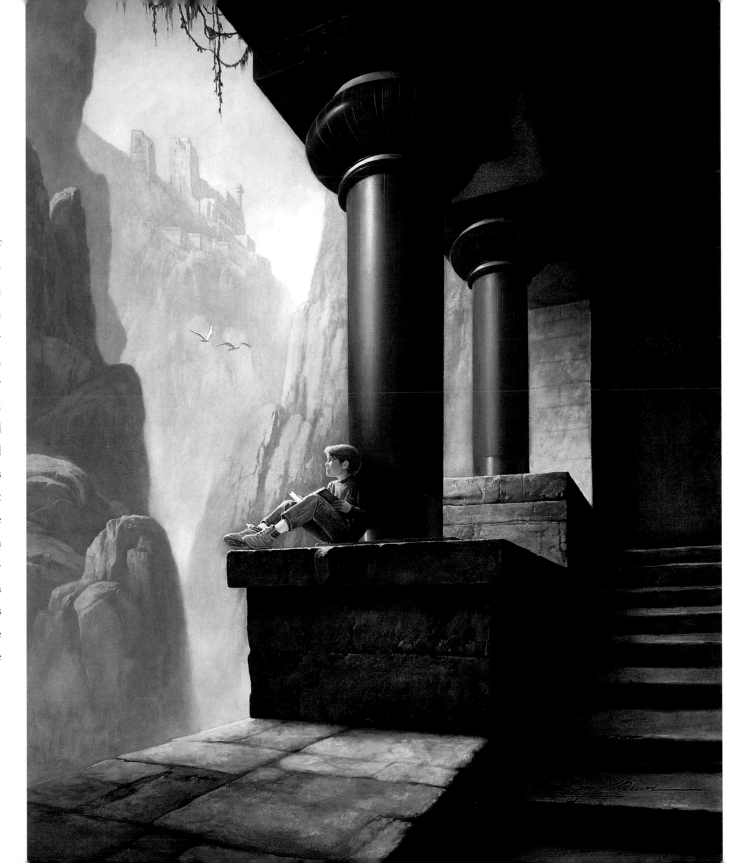

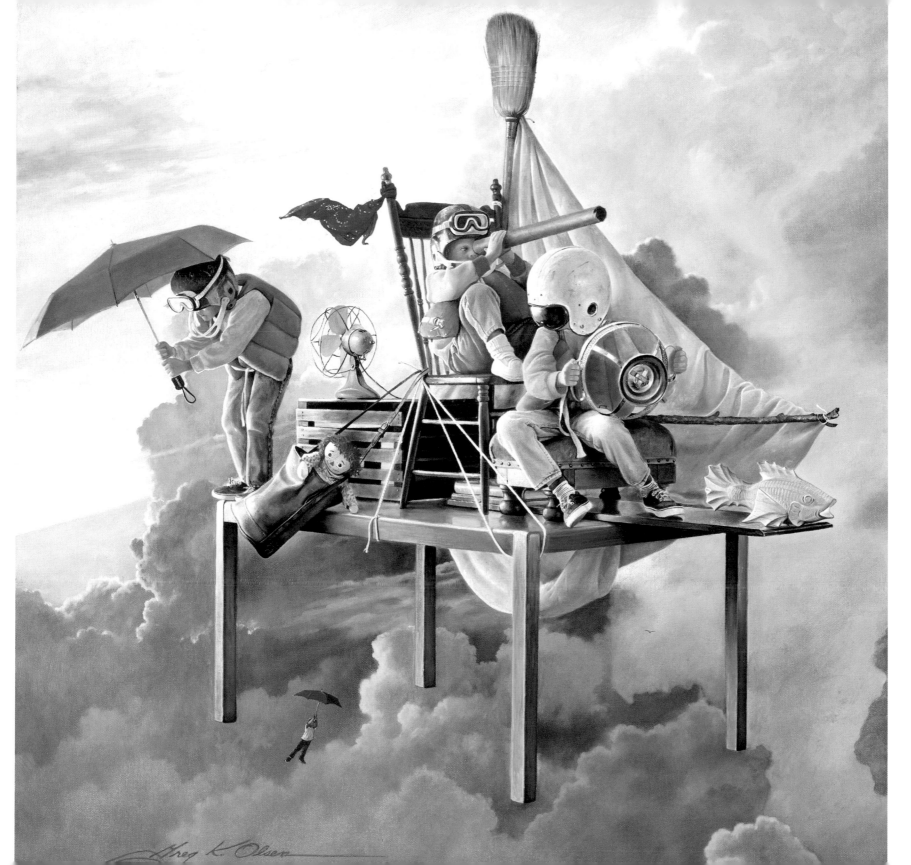

Airship Adventures

All aboard the kitchen table
for a journey to the sky!
It's now our magic airship,
and it can really fly!

Off to new adventures,
above the clouds we go,
Sailing on imagination's breeze,
we leave the earth below.

For fun we like to parachute
and quietly float down,
And have our vessel pick us up
before we hit the ground.

Up here there are no limits
to the sights that one can see,
And we think that we could
sail forever
into eternity.

Then comes the call
that sends us home
as fast as we are able,
It's dinnertime,
and Mother says
we have to set the table.

— GREG OLSEN —

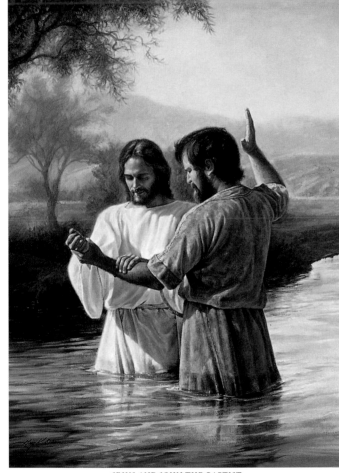

JESUS AND JOHN THE BAPTIST

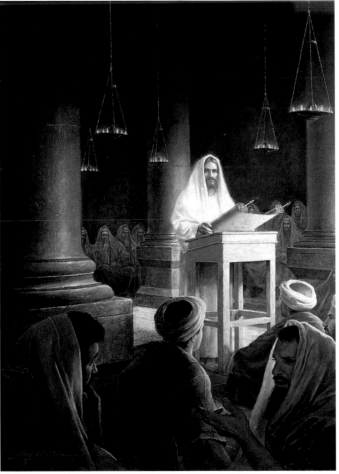

JESUS IN THE SYNAGOGUE AT NAZARETH

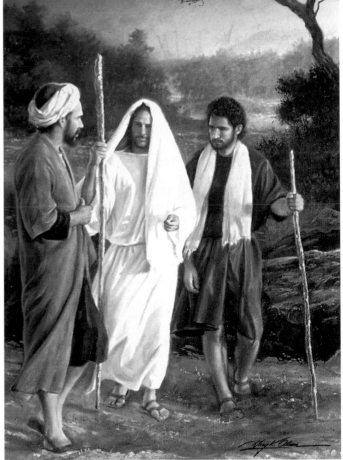

ROAD TO EMMAUS

He Is Risen

Easter morning began full of magic and joy as our little children searched for eggs to fill their Easter baskets. That magic seemed to evaporate when our six-year-old daughter, Kylie, *found out* about the Easter Bunny. This led to a discussion about the Tooth Fairy, leprechauns, and finally, Santa Claus. It was sad to see some of the childhood wonderment disappear from her eyes. Later in the morning, I found Kylie curled up on the couch, looking even sadder than before. Upon questioning her, she said, "Dad, does that mean that all that stuff about Jesus and Heavenly Father is just pretend?"

I sat next to her, gathered her up in my arms, and told her that I was happy to say that I know that Jesus and Heavenly Father are not pretend—They are real!

This painting reflects that belief. On that first Easter morning, the Risen Lord Himself reassured a sad and questioning Mary Magdalene that He is real and that, yes, He lives!

— GREG OLSEN —

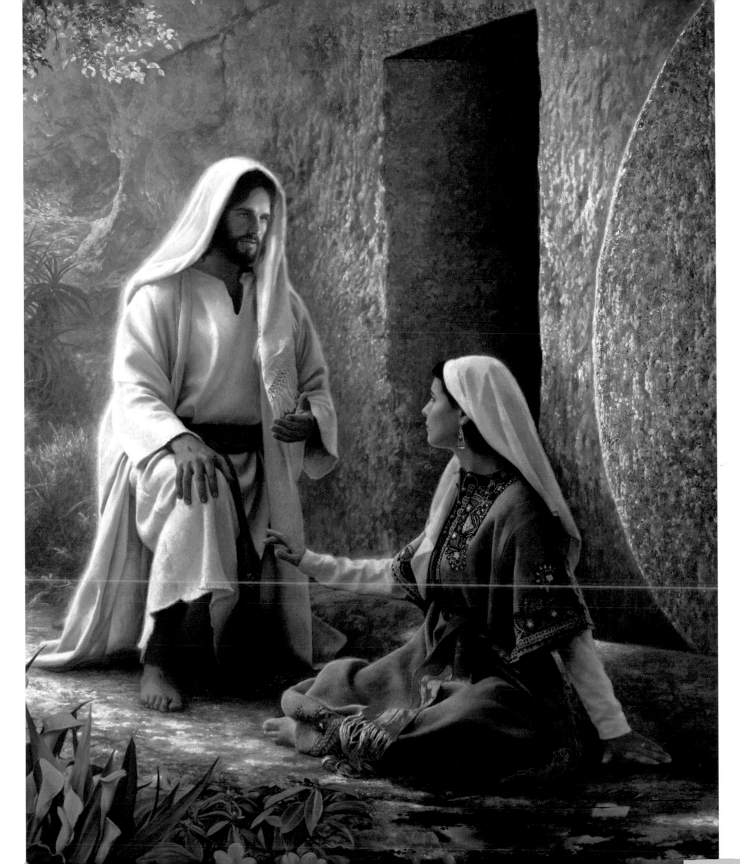

One Man's Trash Is Another Man's Treasure

These young children are in the enviable state of not yet having learned that raking leaves is supposed to be work. They have turned a chore into pure fun. The reward of their raking is the creation of a mountain of leaves large and soft enough to catch them as they jump from the branches of the tree above. All this, while a neighbor leans on a rake in his garden in front of a trash pile of burning leaves.

— GREG OLSEN —

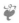

Pots and Pans Band

Kids often seem to march to a different drummer. In this impromptu 4th of July parade, they demonstrate their own God-given independence and creativity. Certainly they are making a "joyful noise," a noise that hopefully will resound throughout their lives.

— GREG OLSEN —

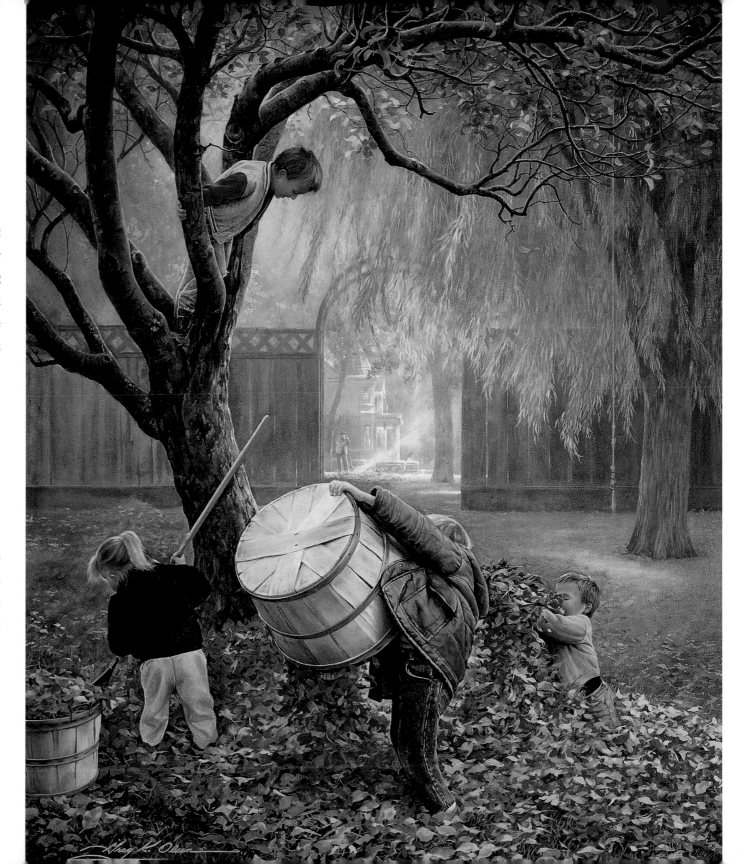

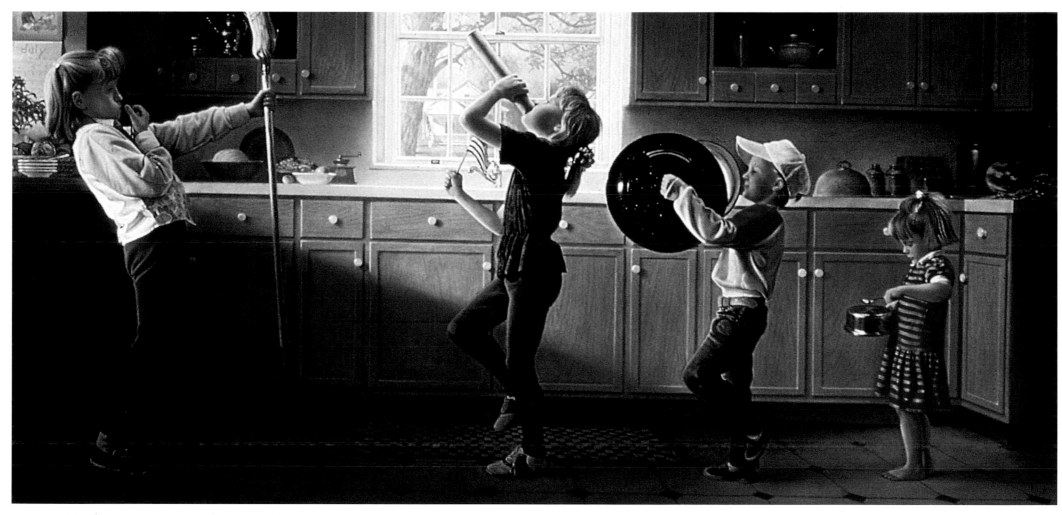

OPPOSITE: ONE MAN'S TRASH IS ANOTHER MAN'S TREASURE. ABOVE: POTS AND PANS BAND.

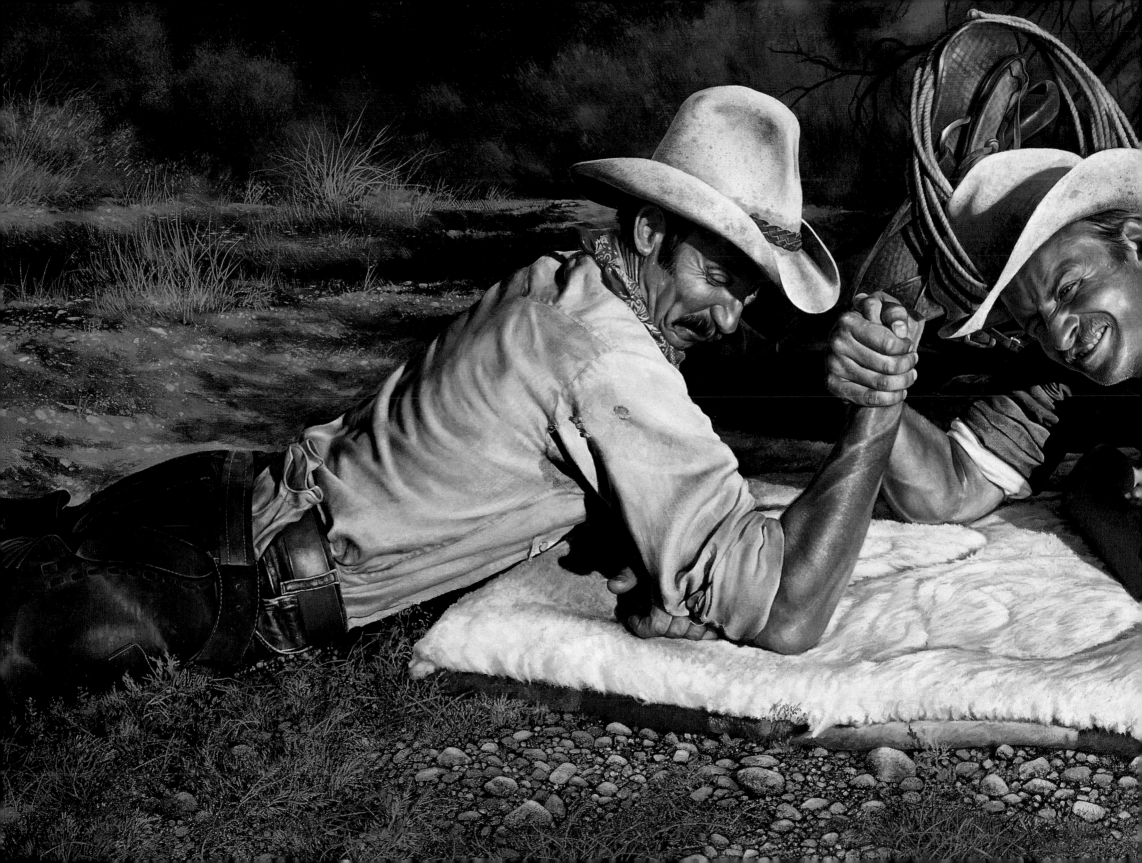

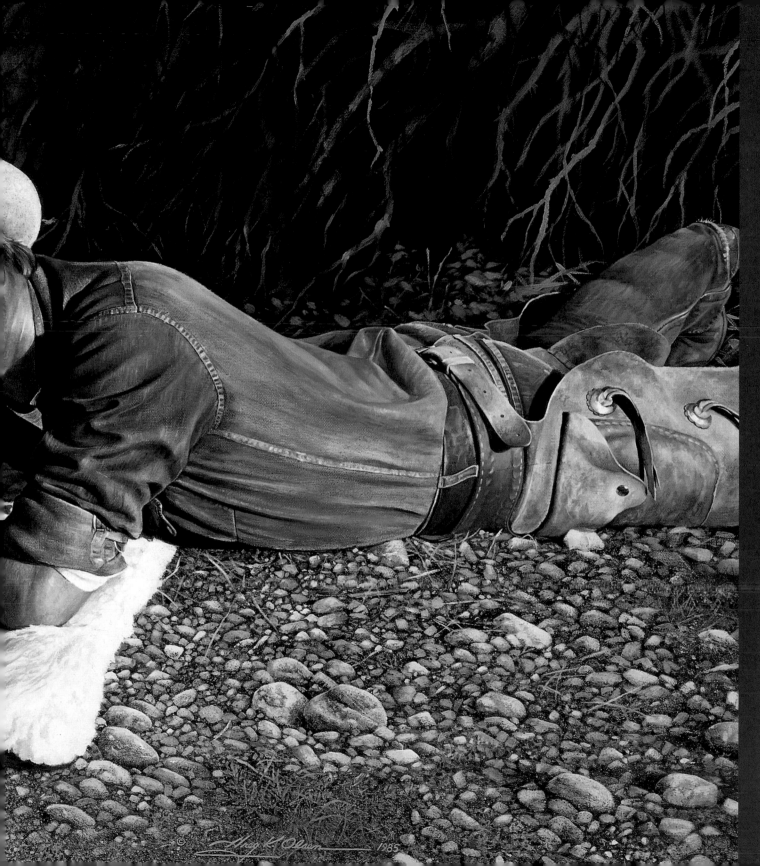

The Arm Wrestle

Friendships sometimes come with struggles, strife, and differences. One person's will or opinion becomes pitted against those of another. Each side is determined to emerge the victor. That scenario, however, always leaves someone feeling defeated. In those situations, humor has often proven to be the splash of water that extinguishes the flames of anger and contention. No contest is worth the loss of a friend. There is wisdom in the advice to "let not the sun set upon your anger." Friendships are worth our efforts, for wealthy is the man who enjoys the company of friends!

— GREG OLSEN —

13

LEFT: THE ARM WRESTLE. ABOVE: EATIN' BEANS.

Delicate Balance

14

Many of my nostalgic childhood memories have as their backdrop the posts and rails of my grandparents' front porch. Reminiscing about those carefree summer days brings back the subtle fragrance of blooming flowers, the aroma of baking gingersnaps, and the taste of fresh lemonade.

A squeaky wicker chair seemed to offer a front-row seat to the rest of the world as it paraded by. The smooth, painted rails were straight and narrow. They provided challenging balance beams that tested the surefootedness of little feet. The sturdy porch posts were official places of safety during our neighborhood games of tag. That porch symbolized the security of home and family, where wisdom passed from one generation to the next.

Years later, those simple lessons learned on that old front porch continue to add balance, perspective, and enjoyment to my life.

— GREG OLSEN —

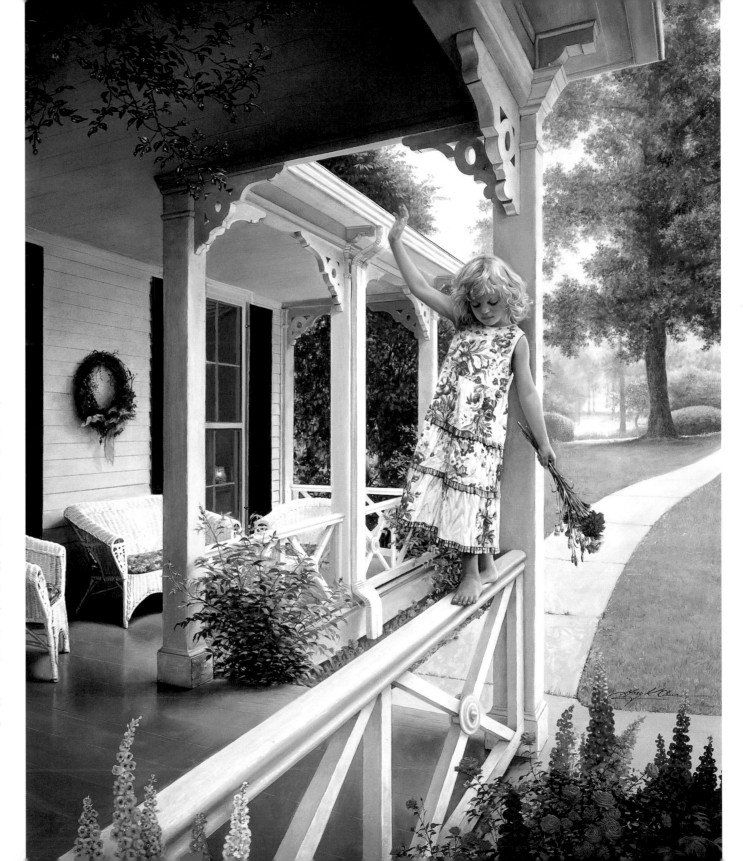

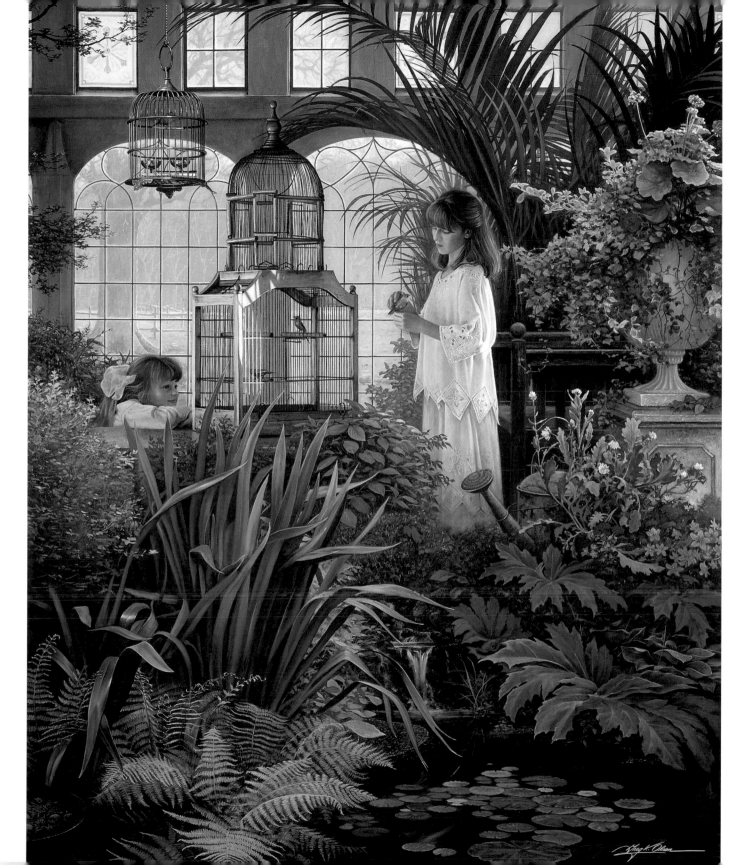

Summerhouse

Step inside the summerhouse and stay a little while,
Walk beneath the palm fronds across terra-cotta tile.

Feel the sweet, damp air, warmed by sunlit windows,
Smell the lush green foliage, the blossoming primrose.

Birds sing their cheerful melodies, perched in Victorian cages,
Their songs are soothing remedies, familiar through the ages.

Water cascades transparently and trickles into pools,
Tiny droplets catch the sun and sparkle like rare jewels.

The garden in the summerhouse blooms in every season,
Year-round it is paradise—for this there is a reason:

Inside there is protection from the chilling winds that blow
and the threat of killing frosts that lay young blossoms low.

Deep inside the summerhouse is a refuge from the storm,
A place that's green and lush, a garden safe and warm.

Step inside your summerhouse and stay a little while,
Your cares will all evaporate on terra-cotta tile.

— GREG OLSEN —

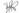

Side by Side

Bosom buddies in a pillowed nest,
Snuggle safe and warm, side by side;
Bathed and fed and ready for bed,
With giggles and whispers to confide.

Flannel-wrapped and satin-trimmed,
To keep them nice and cozy,
With shiny hair so clean and fresh,
Their skin glows soft and rosy.

Sharing a favorite picture book,
Until both become sleepy-eyed,
Near or apart, within each heart,
Best friends forever . . . side by side.

— GREG OLSEN —

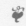

Confidant

It's so nice to have a friend
Who listens to every word you say.
Who always seems to be there
Any time of day.

One who loves you for who you are,
And knows just what you need.
One who shows they care about you
through little kindly deeds.

A friend who'll keep your trusted secrets
Never to reveal,
A friend like this is such a treasure
Especially when they are real!

— GREG OLSEN —

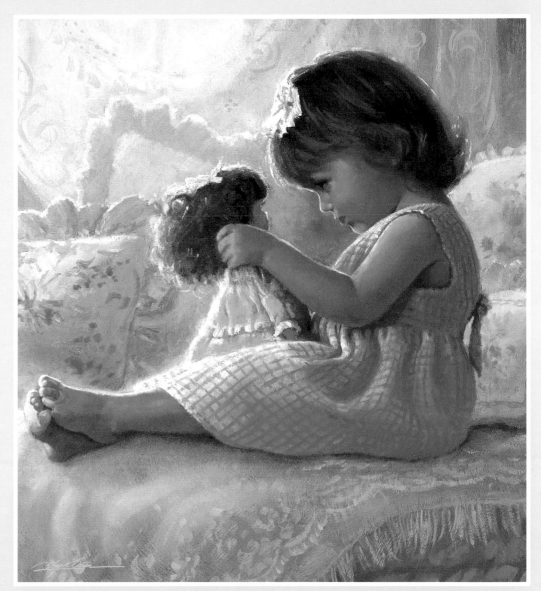

OPPOSITE: SIDE BY SIDE. ABOVE: CONFIDANT.

Dress Rehearsal

Listen! Music fills a room
Like soft sunlight through sheer lace curtains
And those simple youthful melodies are played
Time and time again.

At first with fumbling fingers
And then with practiced perfection
The work soon becomes second nature.
The notes have not changed but the student has.

With each lesson learned another page is turned
And the cycle begins anew.
The young ones observe those older
And follow in their path.

Each maestro has their mentor
And each pupil their faithful fan.
There is pleasure in each performance
Be it childish or complex.

And we seem to enjoy the recitals most
Not when judged in a contest,
But rather when shared in a concert,
Where every soul resonates with a music uniquely its own,

A music which becomes richer
As it harmonizes with that of others.
Our life is but a picture within a picture,
A single note within a score.

Let us use it well.
Let us seek to learn and then learn to share
So that each day is a dress rehearsal
For a grand performance yet to come!

— GREG OLSEN —

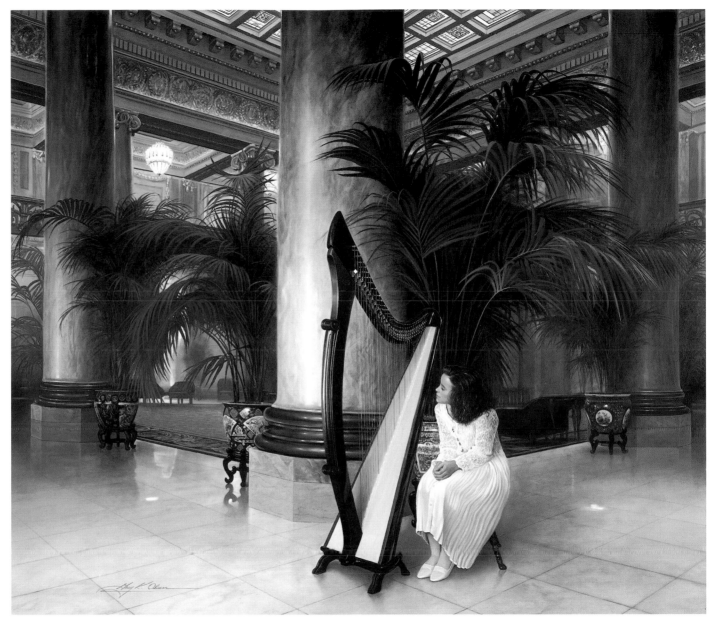

19

OPPOSITE: DRESS REHEARSAL. ABOVE: PRELUDE.

Prelude

A blossoming young musician sits in quiet anticipation of her approaching performance. Tentative but talented, her music is waiting to be released. Oliver Wendell Holmes said: "Many people die with their music still in them. Why is this so? Too often it is because they are always getting ready to live. Before they know it, time runs out." Beware of spending your days stringing and unstringing your instrument, while the song you came to sing remains unsung. Everyone has "music" waiting to be released, and this young harpist is a reminder of that. So go on, let the performance begin! — GREG OLSEN —

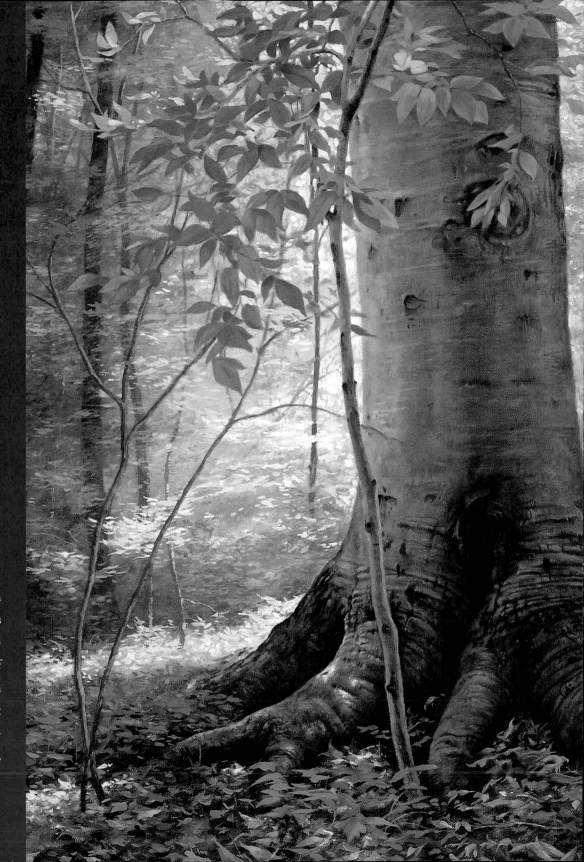

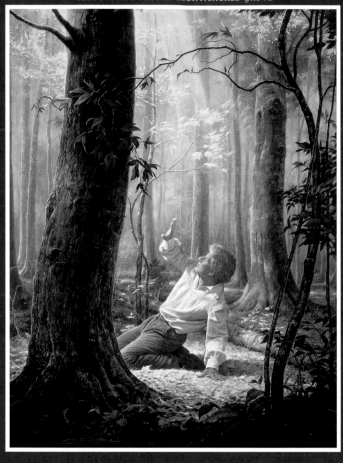

Sacred Grove

The shady cathedral of the woods has long offered a retreat to the soul seeking communion with nature and her Creator. The trees rise like mighty spires, lifting our gaze and our thoughts heavenward. Layers of leaves are illuminated like stained glass windows as the morning sun filters through them. The delicate notes of songbirds float like a hymn upon the still air. Rays of light stream down from the windows of heaven, warming the forest floor below. They rest upon one's being and take away the chill of darker hours. It is in quiet places and in simple ways that heaven's veil is parted for those who knock upon its door . . . such was the case with a 14-year-old boy named Joseph Smith who went into a grove of trees to pray. The young man knocked, and the Father and His Beloved Son simply answered.

— GREG OLSEN —

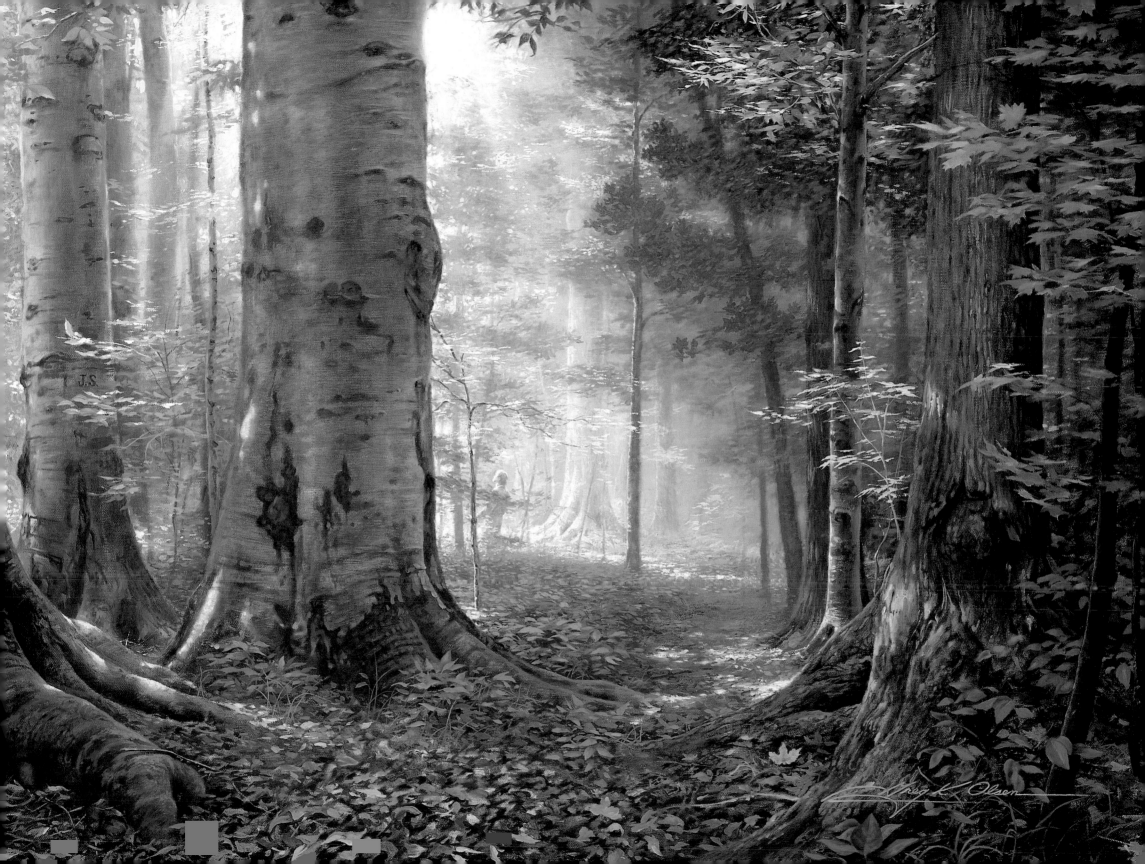

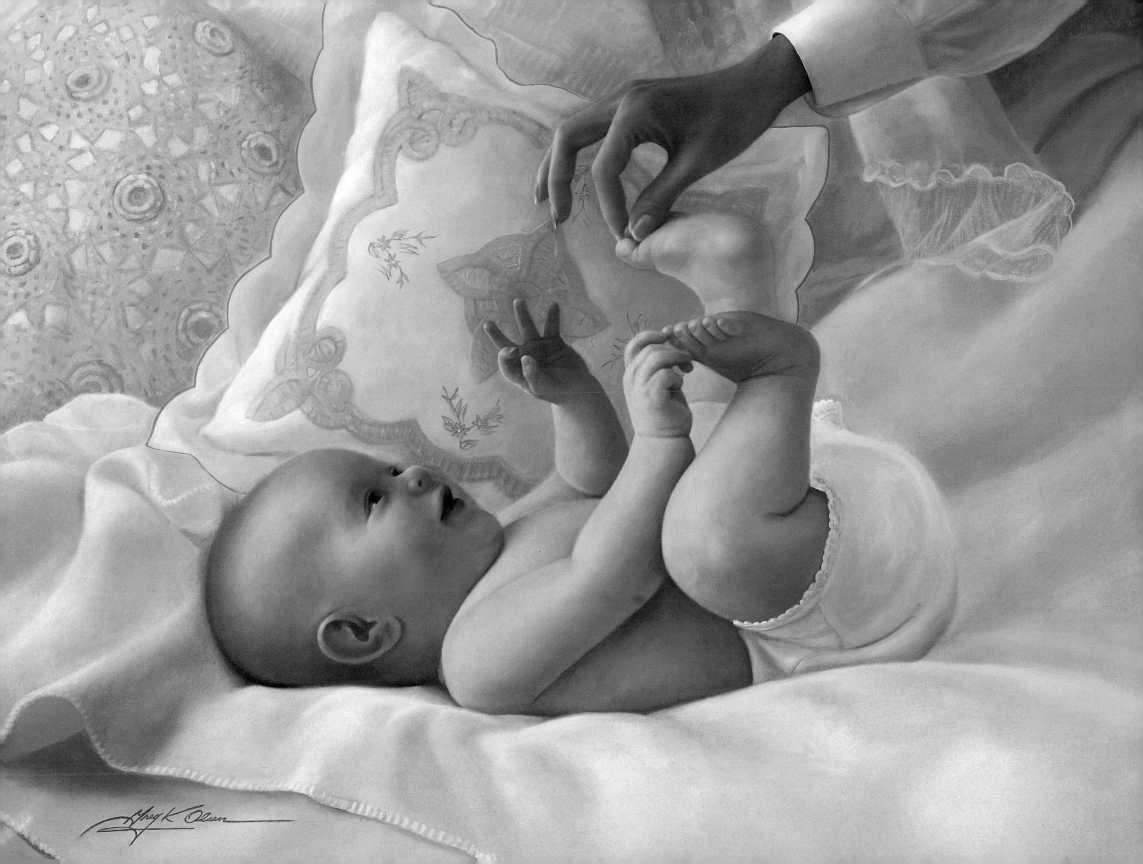

Daddy's Little Girl

It doesn't seem so long ago
that her mother placed her in my arms.
Back then, I held her close to me,
to keep her safe from harm.

We chose a name to give her
and looked forward to the day,
When she would speak her first words;
maybe "Daddy" is what she'd say.

It was just a minor disappointment
that caused my brow to furrow,
When she made the sound of "mama,"
even though she's Daddy's little girl.

Now I look and see she's growing up;
the years fly by like days,
I'd love so much to keep her young
and watch the way she plays.

She dresses up and acts the part
of a bride on her wedding day.
And my eyes grow moist when I realize
that someday she'll go away.

It doesn't seem too far off
when another will take her from my arm,
Giving her a different name,
and so I ask, "Please keep her safe from harm."

Someday she'll be a woman,
with her own future to unfurl,
But in my heart, I'll hold her close;
forever Daddy's little girl.

— GREG OLSEN —

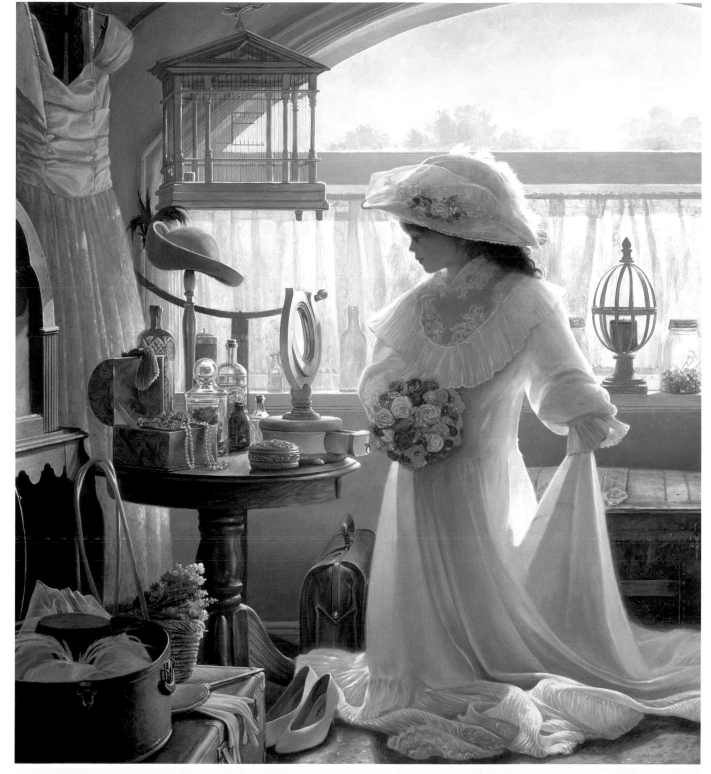

OPPOSITE: HEAVEN SENT. ABOVE: DADDY'S LITTLE GIRL.

Little Girls Will Mothers Be

A mother sits by her cradled child,

A Sunday sun warms the moment mild.

She sings lullabies and at storytime,

Reads fairy tales and nursery rhymes.

Pictures are painted with a tender voice,

Memories are made, lasting and choice.

Though the little one understands not a word being said,

It's the love that is heard, not the words that are read.

Down through the ages the scene will abide,

Of a small cooing babe and a mother beside.

Now look even closer at this mother petite,

No ring on her finger! Shoes? On the wrong feet!

And she can't really read to the child that we see,

But we smile 'cause the child is a doll and the mother's just three!

The pages are turned by a little girl,

Acting so motherly in her make-believe world.

She's learned by example and been endowed from above,

It seems very natural, this motherly love.

And so with turning pages we shall see,

That soon little girls will mothers be!

— GREG OLSEN —

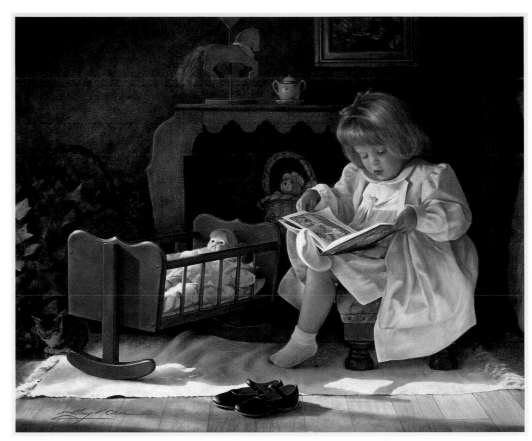

ABOVE: LITTLE GIRLS WILL MOTHERS BE. OPPOSITE: MOTHER'S LOVE.

Mother's Love

I saw this mother and child in a sort of haven, a place of shelter and safety, a refuge from the world. There is no greater haven than the strength of a mother's love. A child who knows and feels that love grows strong there in fertile soil. The haven of a mother's love is the hope of each new generation.

— GREG OLSEN —

24

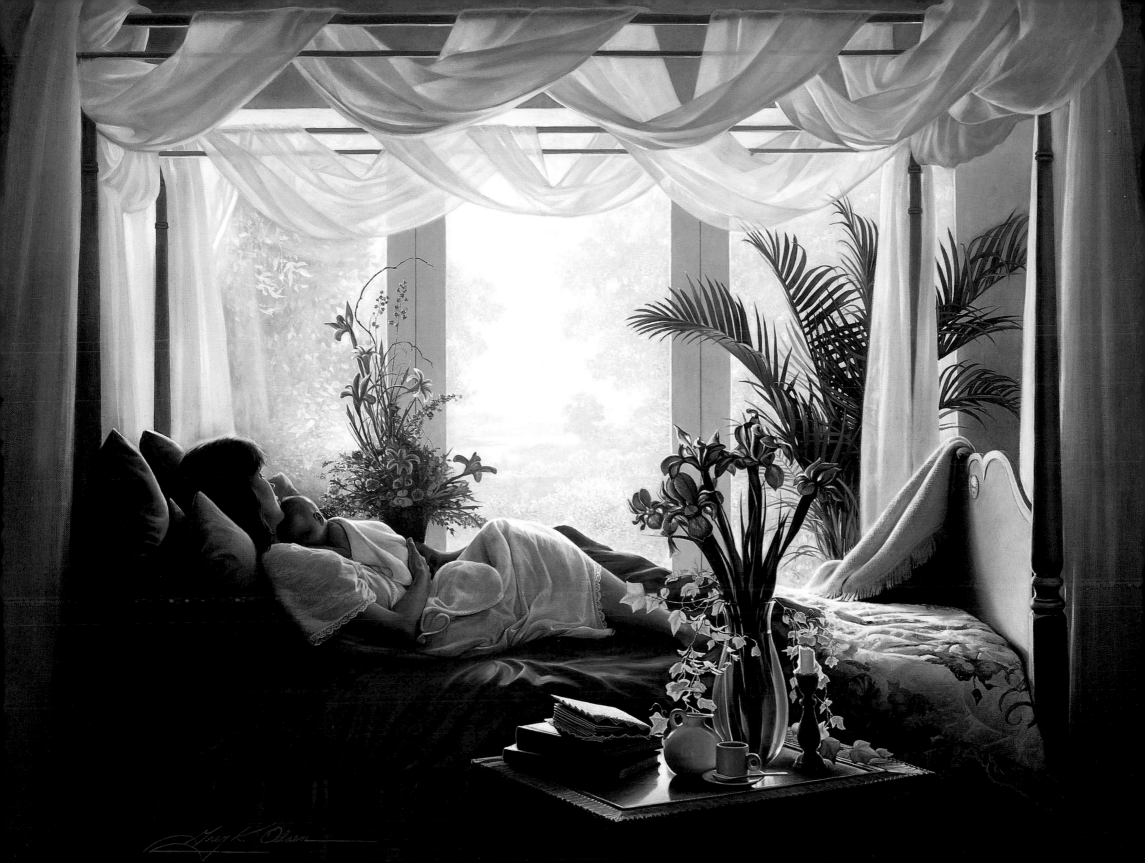

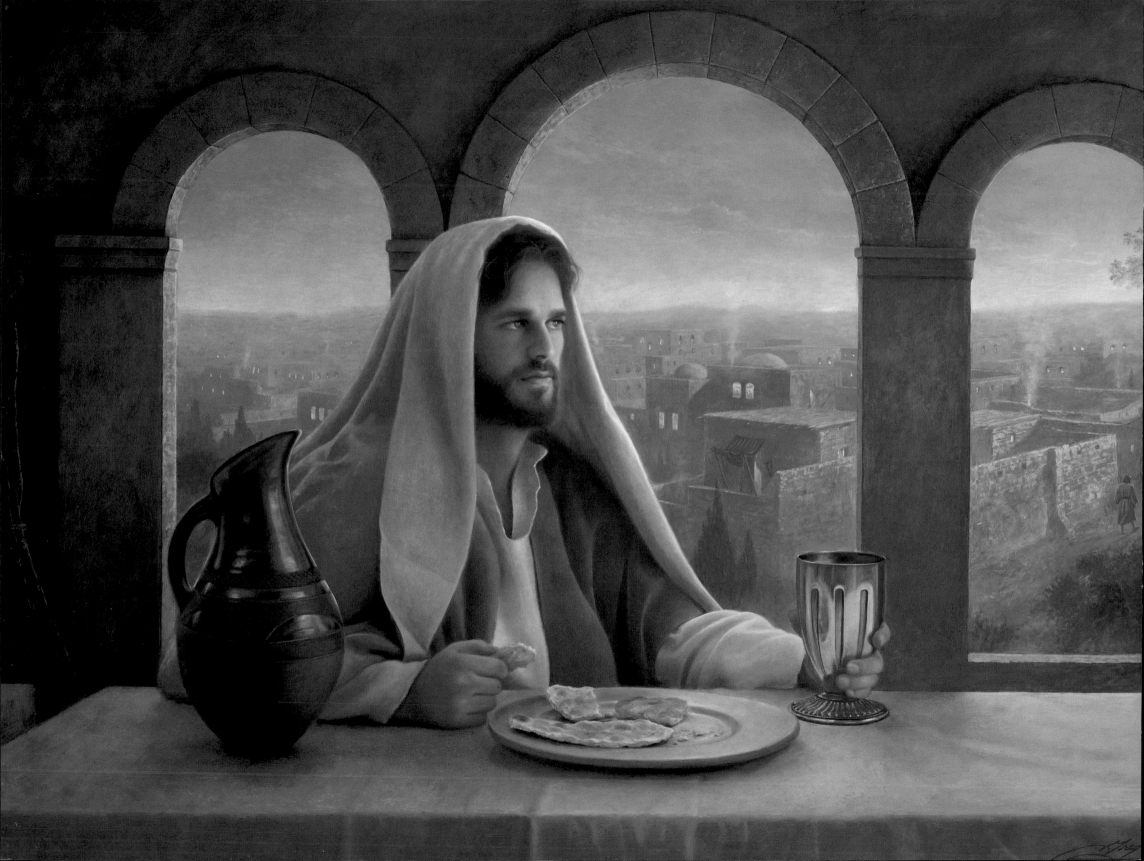

In Remembrance of Me

Inspiration often comes in unexpected ways. My approach to this piece was influenced by a rather unusual source—a photograph of John F. Kennedy. It was taken at a moment when the world was on the brink of war—the height of the Cuban missile crisis. Although President Kennedy was surrounded in his oval office by cabinet members and military advisors, he alone bore the weight of making those final critical decisions. The photographer cropped everyone out of the picture except the President. He focused on capturing the President's expression, which tells the story of this pivotal time in history.

Nearly two millennia earlier, the Savior sat in an upper room. The world was on the brink of another kind of war, a great struggle between good and evil, a very real battle for the souls of all men and women. Though surrounded by His beloved apostles, the weight of the world's sorrows—past, present and future—rested on Him alone. No one else could comprehend what lay ahead in the dark shadows of Gethsemane or upon the rugged cross at Calvary.

This Last Supper marks the beginning of the end. Judas has silently departed and is on his way to complete his treacherous bargain. The time has come for Christ to "suffer all things." Though understandably apprehensive, and wishing, even praying, that this cup might pass from Him, He nevertheless submitted His will to that of His Father. He went on to drink the bitter cup and drain the very dregs—because He loves us! In return He asks only that we remember Him, and in doing so, we are inspired to be more like Him.

— GREG OLSEN —

Castles in the Sky

Like boys who build their castles from little blocks of wood.
And imagine that they are king today of all that's great and good;

We men build our own walls, perhaps of granite stone,
And proudly sit within those walls upon our self-made throne.

Foolishly we climb our highest tower and look across the land,
To see if someone else's castle upon a higher hill might stand.

Then gazing at the flying clouds and sinking sun of day,
A memory stirs from deep inside of castles far away;

Splendid ones with spires of light and towering walls of gold,
With stairs that we have climbed and streets that we have strolled.

More glorious than tongue can speak are the sights
of a scene thus filled,
But the heart cries a familiar, YES!—These castles are real!

Tho' here our home may be palatial, each courtyard with
fountained pond,
Yet all are but scanty similes of these castles far beyond.

And so our mortal homes, be they quaint or be they grand,
It matters not at all, for none of these will stand.

Granite stone like wooden blocks will tumble down someday,
And off we'll fly into the clouds and there in a castle stay!

— GREG OLSEN —

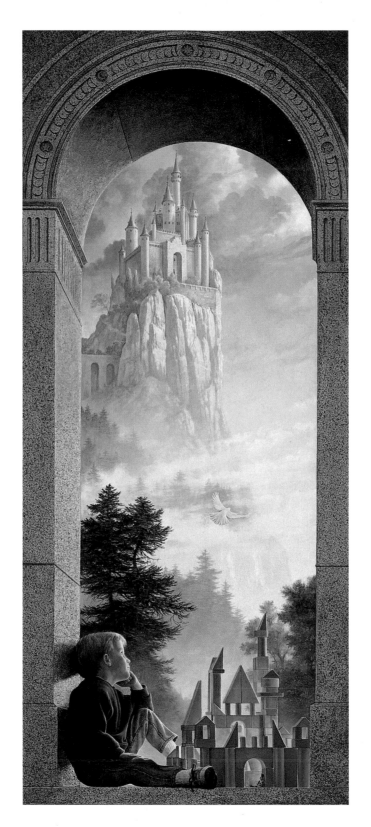

Bon Voyage

Out the call went, 'twas the day to embark,
"All aboard on Noah's gopher-wood ark!"

They came, every creature; they came, two by two,
They all came for a ride on that big floating zoo.

When they arrived, some could not understand,
How a boat could be made to float on dry land!

They searched for an answer, but none could be found,
Because, quite simply, there was no water around.

Noah, undaunted, said, "The Lord will provide.
Please grab your partner, and then come inside."

But a few of those creatures were still filled with doubt,
They said to the others, "You go ahead; we're staying out."

Then they started to laugh, and they started to mock
"The poor foolish creatures" in line at the dock.

"Bon Voyage! Please have a nice trip;
Send us a post card," they yelled with a quip.

Amidst taunting, the last passenger boarded the ark,
The door was shut tight; the sky began to grow dark.

While slapping their knees, they roared at the ship,
And while shaking their heads—one felt a drip.

And thus, the question is answered, as it thunders and pours,
As to whatever happened to all of the great dinosaurs.

— GREG OLSEN —

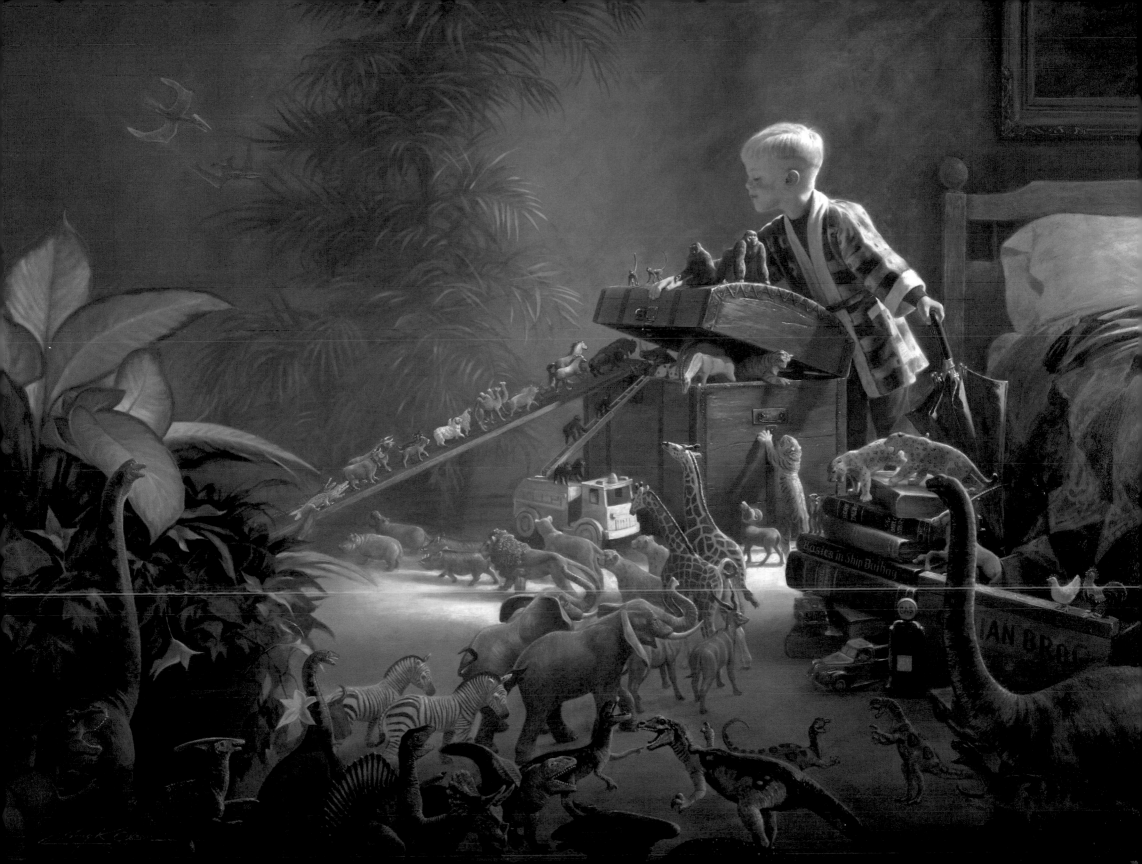

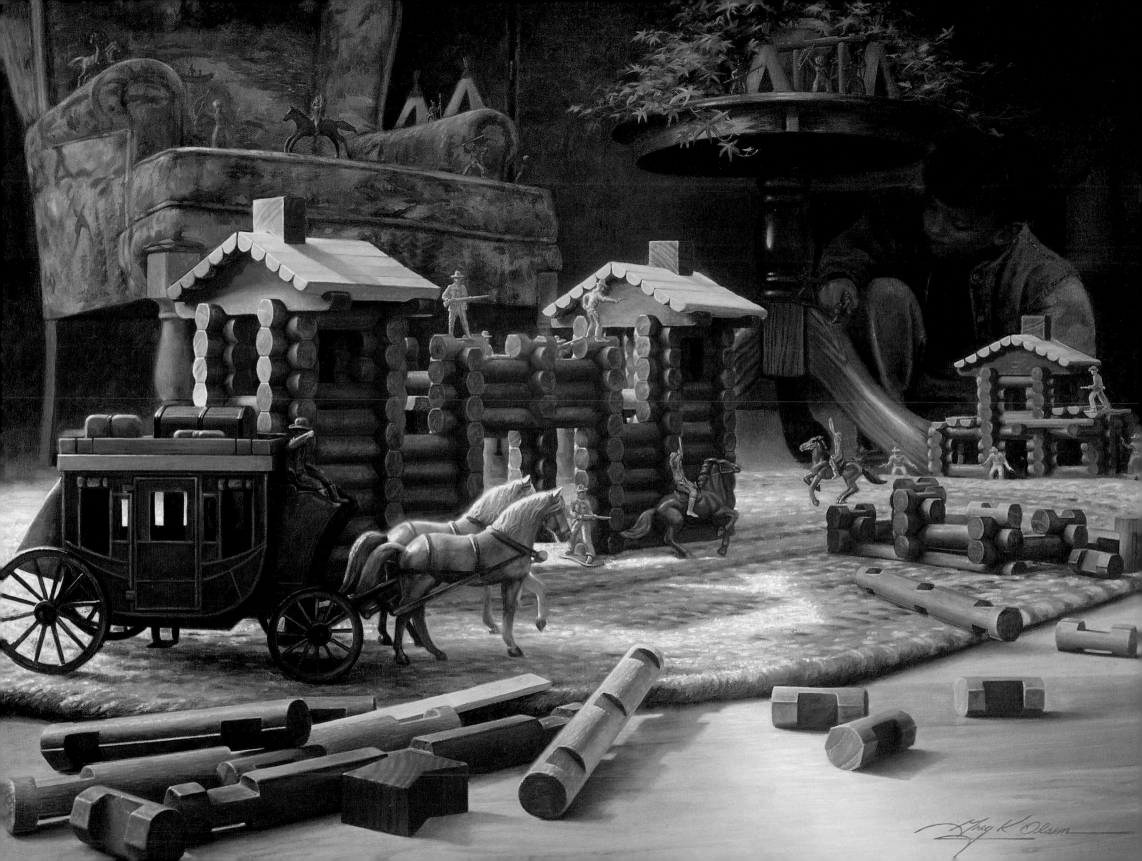

Imagination: The Final Frontier

Imagination shrinks me
till I am very small
And buildings made of Lincoln Logs
now seem so awfully tall.

Every nook and cranny
a place to now explore,
The world looks awfully different
when you're only inches from the floor.

Then later when I get tired
of that little point of view
I imagine that I am big again—
big like me and you.

No longer is my world
a place where I must crawl,
Now my imagined cares and troubles
are not so big at all.

— GREG OLSEN —

OPPOSITE: IMAGINATION: THE FINAL FRONTIER. ABOVE: LINCOLN LOGS.

31

Denim to Lace

A rough-and-tumble tomboy
with sneakers on her feet,
She'll go toe-to-toe with any Joe
she meets along the street.

Her prowess on the playground
has created no small stir,
In fact the star player of the game
was not a him—but her!

She hits and throws and, the story goes,
her fast ball can't be seen,
But beneath the grit and all the grime
can be found a little queen.

The tomboy goes when she changes her clothes
and lays her leather aside,
When the sneakers come off and the slippers go on,
with laces carefully tied.

Then the pitcher does a pirouette
that's like a curve ball she has thrown us,
And with dancing shoes and graceful moves,
a much softer side is shown us.

— GREG OLSEN —

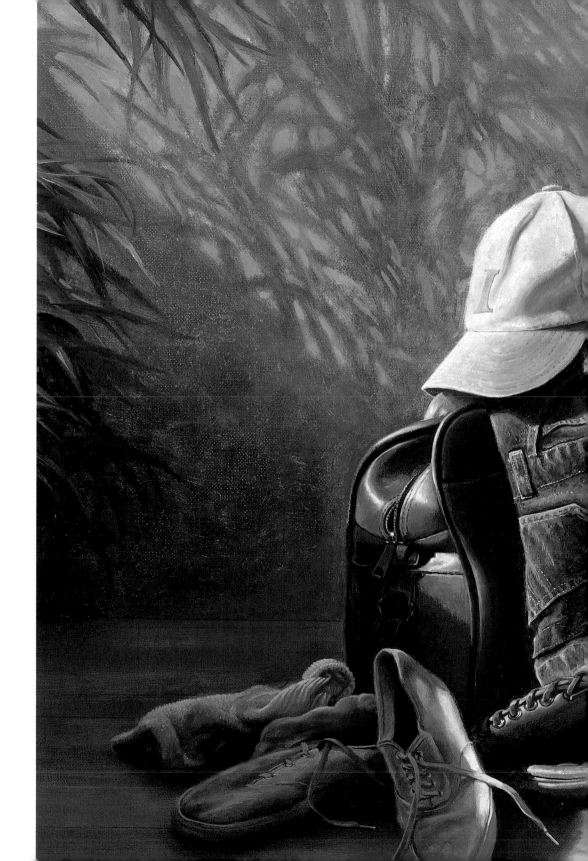

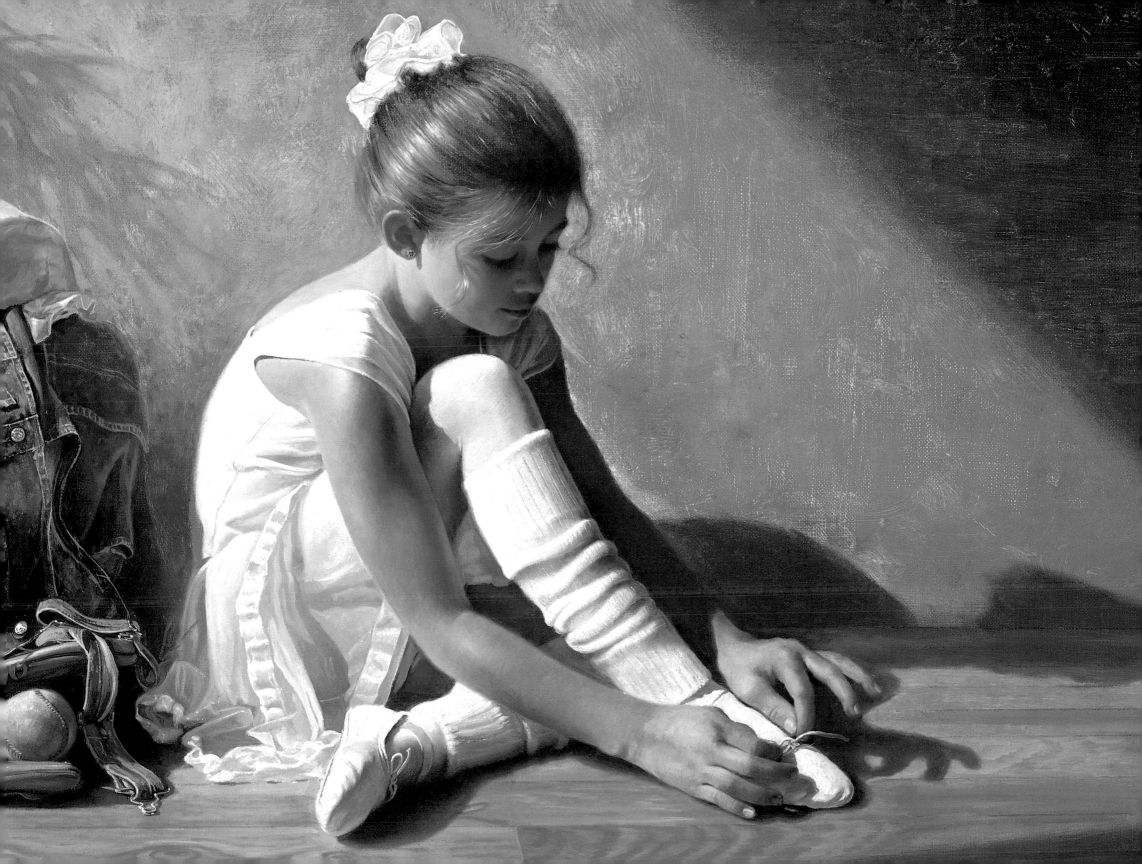

Angels of Christmas

Nativity figures from their box are retrieved
Near a crackling fire on a Christmas Eve.

Each is unwrapped with excited haste,
Then slowly, carefully, thoughtfully placed.

The scene comes to life when viewed by a child,
The babe seems to stir, and the mother just smiled.

Safeguarded here and kept far from danger,
The baby is kissed and laid in a manger.

This night is for children,
and their spirits can lift us,
They are the magic, the guardians,
the "Angels of Christmas."

— GREG OLSEN —

34

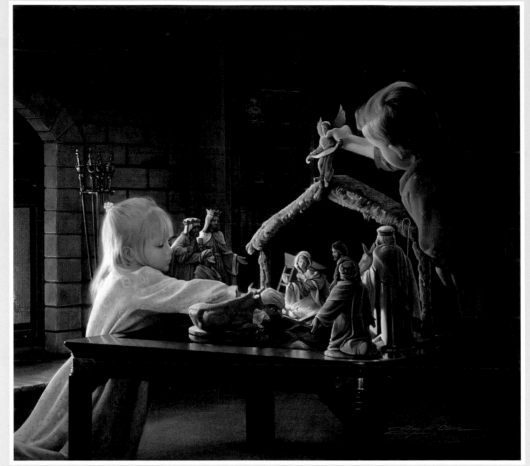

ABOVE: ANGELS OF CHRISTMAS. OPPOSITE: THE REASON FOR THE SEASON.

The Reason for the Season

Enter a wonderland where twinkling lights shine on an array of symbols of the season. From attic hideaways come holiday treasures to cast their spell over the young at heart. The boxes and bows, tinsel and trim, wrap you in a warm, cozy spirit. The ribbons and reindeer, the soldiers and trains turn your mind back to the storefront windows, and you can almost imagine your nose pressed against the cold, frosty glass. Reminders of Santa and sleigh rides, falling snow and shining stars, bring back the excitement of a sleepless December night. Nuzzle a fuzzy teddy bear and hear the sound of a jingling bell or a glistening golden horn. Put yourself into the miniature world of a Dickens village and stroll the winter streets with the shoppers and carolers about. Toylike angel dolls and little snare drums are found beneath the fragrant evergreen. The wafting scent of pine boughs carries you to a magical place called Christmas. All these things form the accessories of the season, the decorations that lift and cheer us, but they only reflect the light of that which shines most brightly, a humble couple and a tiny babe, lying in a manger—the true meaning of Christmas—the reason for the season! — GREG OLSEN —

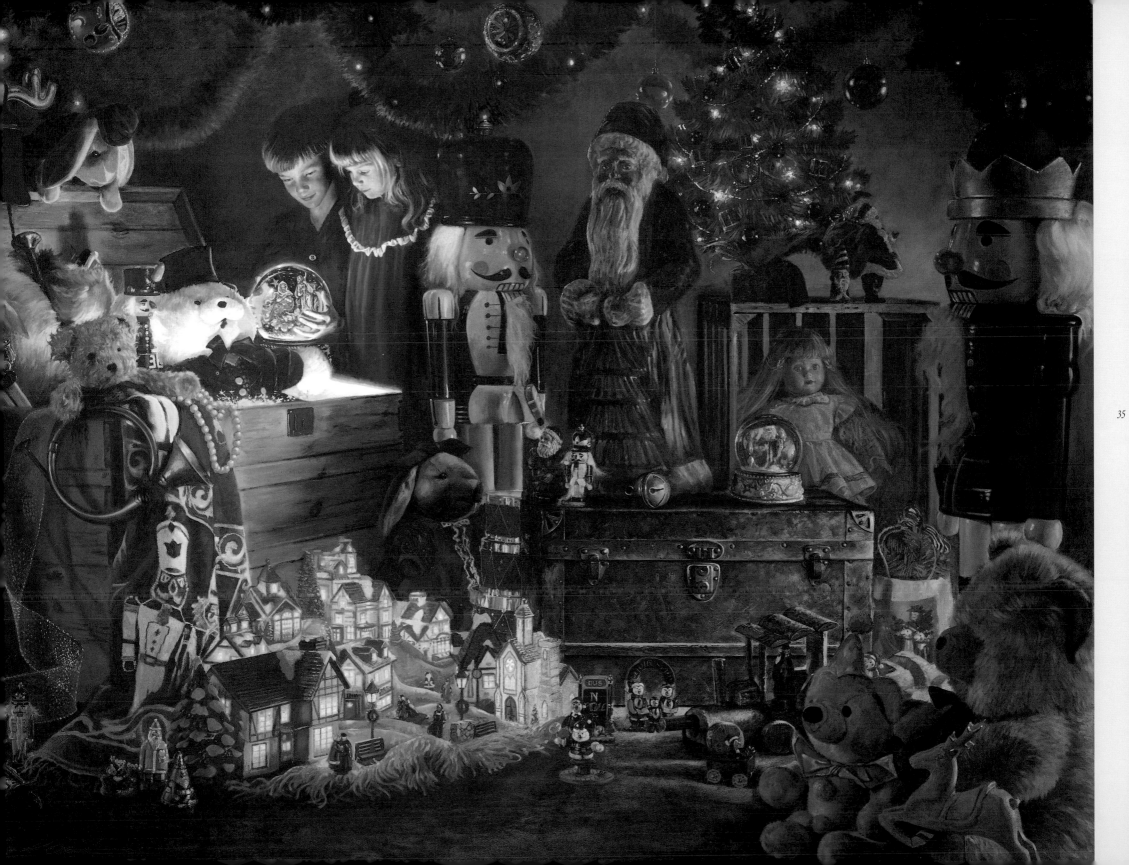

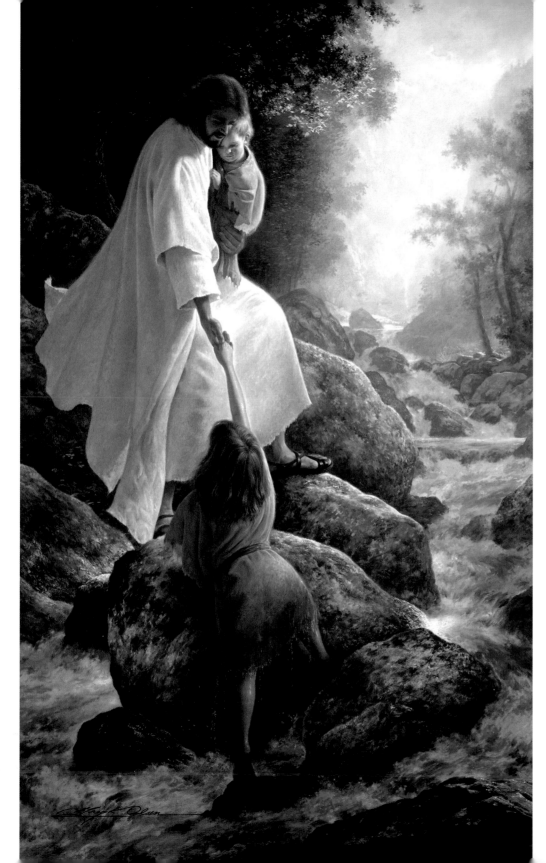

Be Not Afraid

Like children who have lost their way
Alone and comfortless we wander.
Stumbling through woods that grow deep and ever darker,
With no direction, we cry for help
And hear our pleas echo through the canyons.
Is there anyone who can hear us?
Then, like a rushing wind, a voice whispers to our heart.
And through tear-filled eyes, we see an outstretched hand,
There to lead us home.
Though swirling streams may block our way
And slippery stones betray our feet,
He leads us on. He knows the way, His feet are sure,
And in Him we find safe passage.

— Greg Olsen —

O Jerusalem

"O Jerusalem, Jerusalem . . . how often would I have gathered thy children together, even as a hen gathereth her chickens under her wings . . ." (Matt. 23:37). This is a Messianic exclamation of profound concern and unconditional love for all who have lost their way and suffer while wandering in spiritual darkness.

As the slanting rays of the sun reflect upon the rooftops of Old Jerusalem, Christ reflects upon His life's mission and upon those He came to serve and bless. His gaze takes in the glistening gold and marble of Herod's Temple and the smoke of burnt offerings upon the altar. He is keenly aware that soon He will offer Himself up as the true Passover Lamb—the Lamb of God. Here, upon the Mount of Olives, Jesus can see the day, like His mortal ministry, coming to a close.

However, a new day always dawns, and there is hope and comfort in His words, "lo, I am with you alway" (Matt. 28:20). Just as He looked down upon the traveling pilgrims entering Jerusalem, He watches still from yet a higher vantage point, ready to extend His protective wing to all who seek Him.

— Greg Olsen —

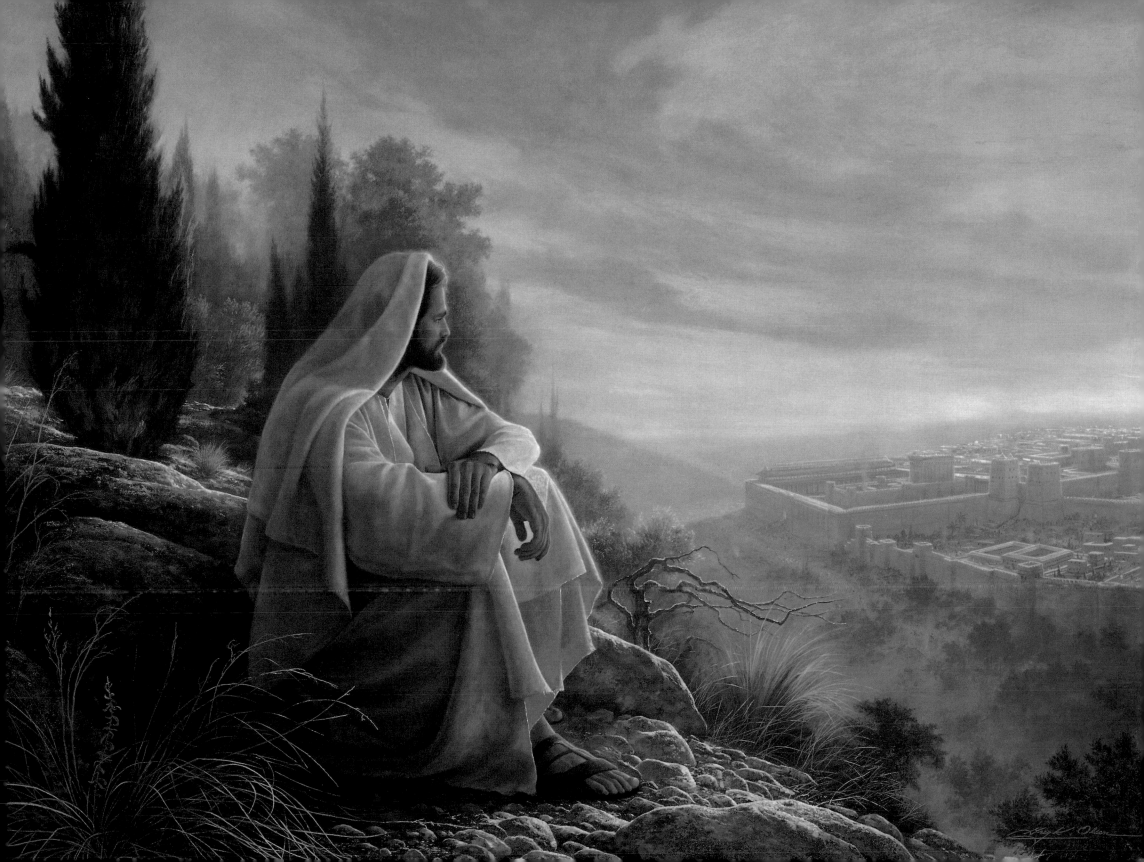

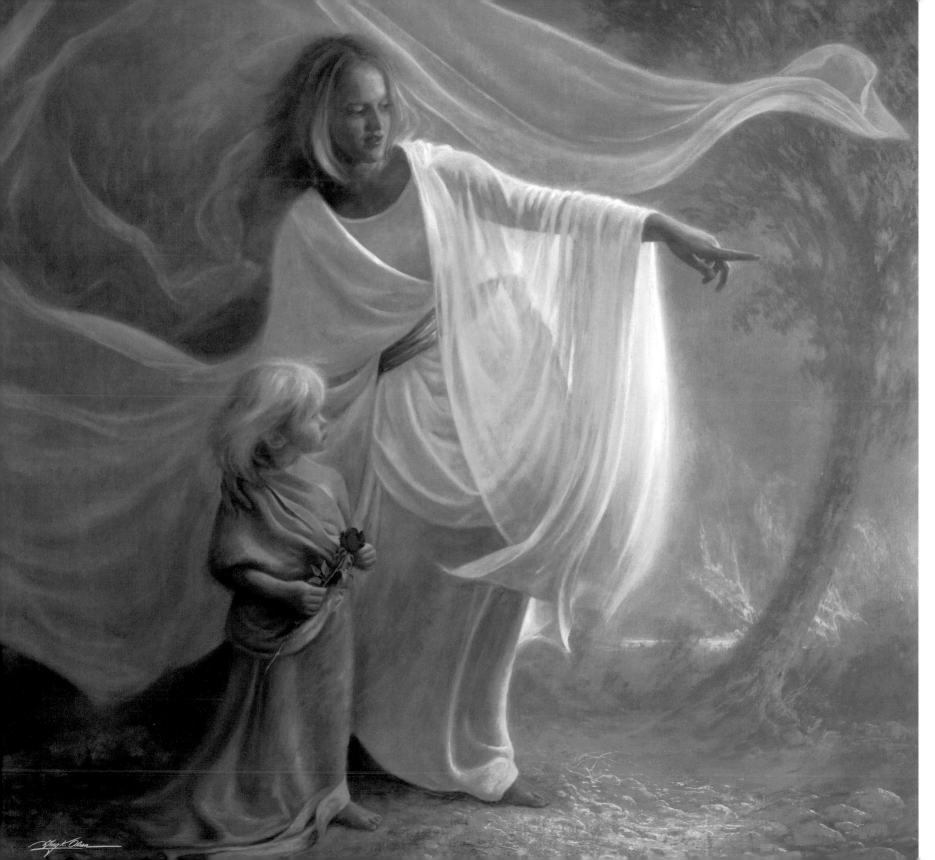

Heavenly Hands

Afraid and wandering,
we lost our way.
With no aid in sight,
we began to pray:

"Please keep us safe
in such hostile lands,"
Then came the warm touch
of Heavenly Hands.

Perhaps one on our shoulder
when we felt alone,
While another pointed the way
which then led us home.

The help came unseen
like the wind as it blew,
But we all felt it upon us,
and that's how we knew

That angels still watch and
sometimes send us a "rose"—
A gift to remind us
that Heaven still knows

All that we go through
and all that we need.
Surely Heaven is with us,
if we'll only give heed.

— GREG OLSEN —

Don't Forget to Pray

When sunlight fades and day is done
and night is drawing nigh,
Don't forget to kneel and pray
and thank the Lord on high.

For all the many blessings
that come from heaven above,
For all your friends and family
and for everyone you love.

For all your happy memories,
that make you laugh and smile,
Even for the growth you've made,
while passing through each trial.

Then ask Him for the help you need
to make it through your week,
Ask Him to comfort and strengthen you
when things are looking bleak.

Ask Him for His guidance to
help you choose what's right;
Ask Him to watch over you
and keep you through the night.

And because He loves you,
He'll listen to what you say.
So, every night, before you climb in bed,
don't forget to pray!

— GREG OLSEN —

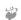

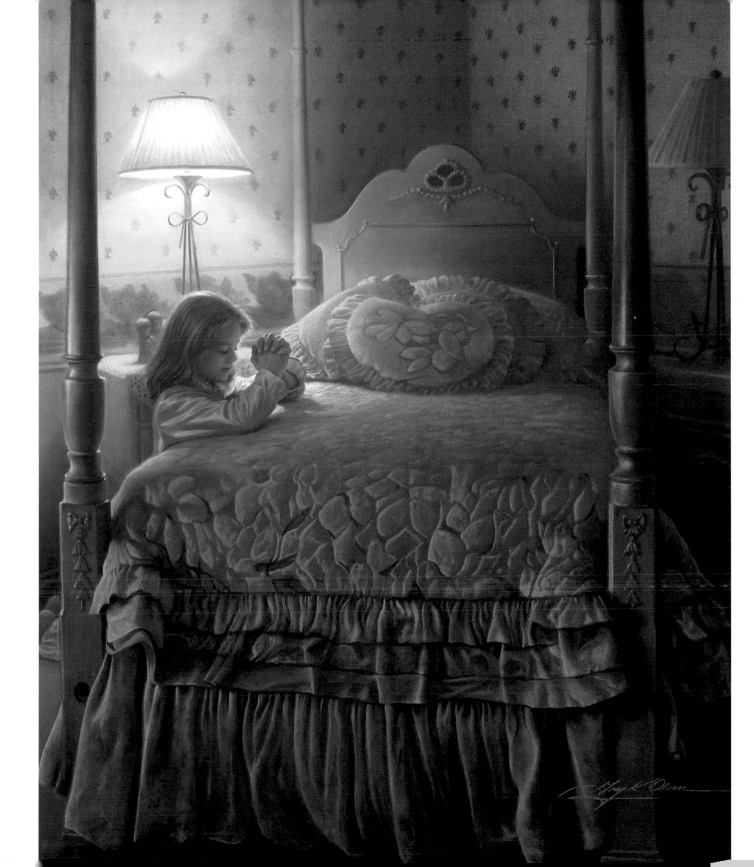

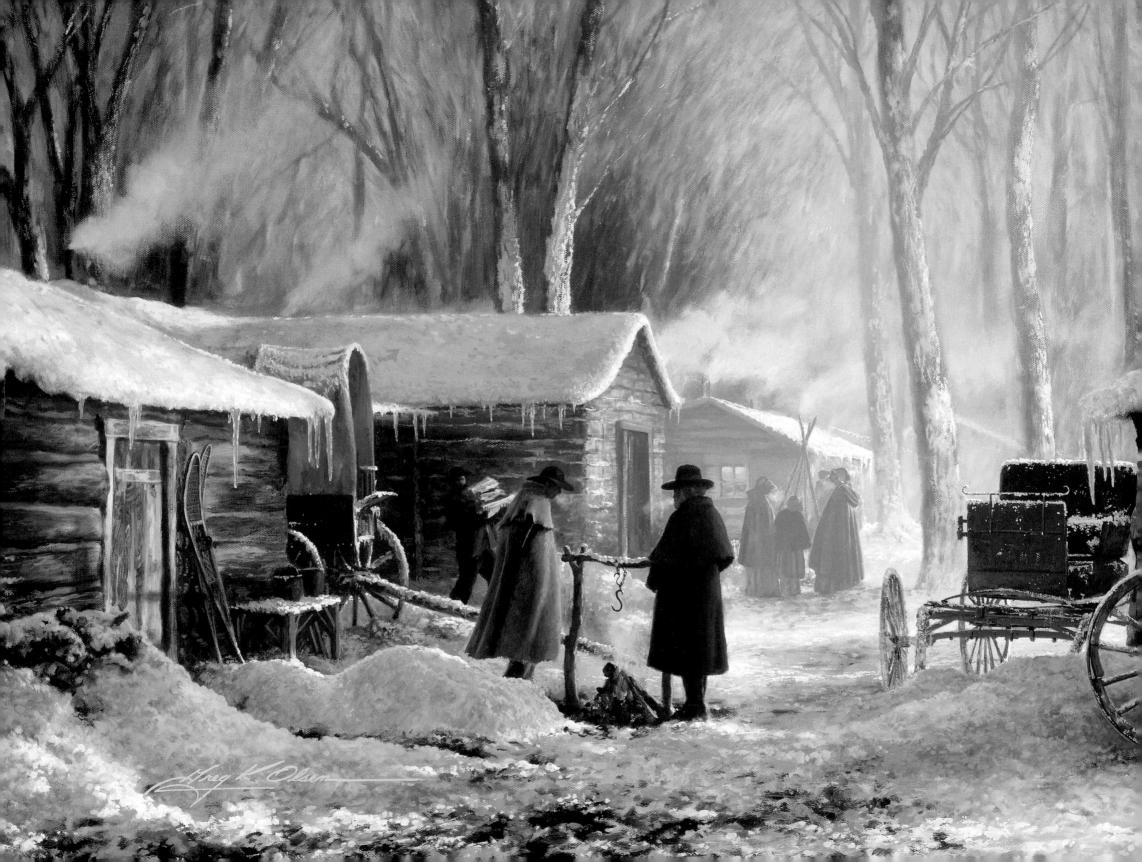

Winter Quarters

The indomitable human spirit is exemplified by the early pioneers of the American frontier, who, in times of great adversity, turned suffering and hardship into opportunities for growth and experience. Many who have gone before us have demonstrated that our inner happiness has little to do with our outer circumstances. The external conditions weathered by these pioneers were often harsh, and winter's severity forced them to take refuge in temporary settlements referred to by trappers and explorers as "winter quarters." Here, in January 1847 near present day Omaha, Nebraska, Mormon pioneer families crossing the land in ox-drawn wagons containing all they owned found a respite from the journey and all the hardships endured along the way.

Yet even within the confines of shelter, tragedy was no stranger. When disease struck, it took a heavy toll, and hundreds would succumb, weakened by inadequate provisions and fatigue. Parents, who had already sacrificed so much, buried their beloved children. Those who were able cared for those who were ill. The fact that these brave pioneers persevered, despite their struggles, suffering, and sacrifices is a testimony to their spirit. Rather than becoming hardened, adversity strengthened their resolve and deepened their communal spirit.

Fortunately, this austere existence did not crowd out of life the joy of living. Laughter, merriment, playfulness, the lively strains of the violin, and the dancing party were still observed. Music and song nowhere and at no time better served their purpose of cheering the hearts of men than in these wilderness encampments. — GREG OLSEN —

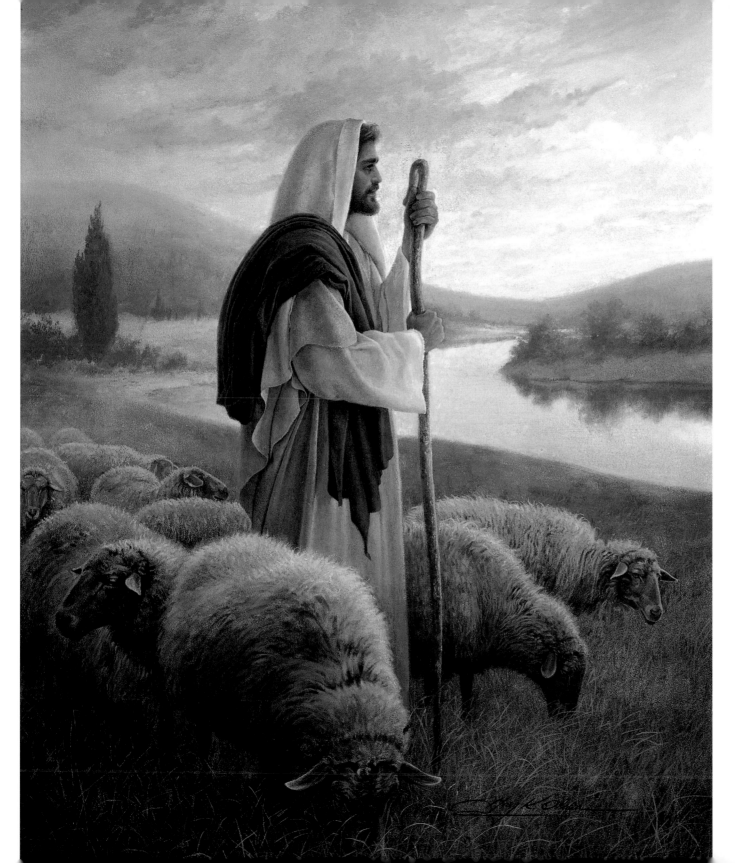

The Good Shepherd

The age-old symbol of the good shepherd has brought peace and comfort to the hearts of many throughout the years. The strong and watchful keeper of the flock, who knows His sheep and is known by them, guides the sheep to green pastures and to still waters where they can graze and safely drink. He gathers them before the approaching storm and searches for those that may be lost. He places Himself between danger and the flock He tends. His sheep recognize His voice, and His call is a call to peace, safety, and contentment.

— GREG OLSEN —

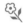

Lost No More

The shepherd and his flock have been ever-present symbols of the Lord and the people of His pasture. The ancient role of a shepherd was much more than an assignment to herd sheep. The shepherd loved his sheep, he knew them, named them, provided for and protected them. In return, the sheep responded to their shepherd and recognized his voice. His call alone could bring them back from their wanderings in unfamiliar paths. If lambs were lost, he sought them out and brought them back to the fold.

Those who hear the Master's call and then seek to follow in His path will find Him and there enjoy contentment and safety at His feet.

— GREG OLSEN —

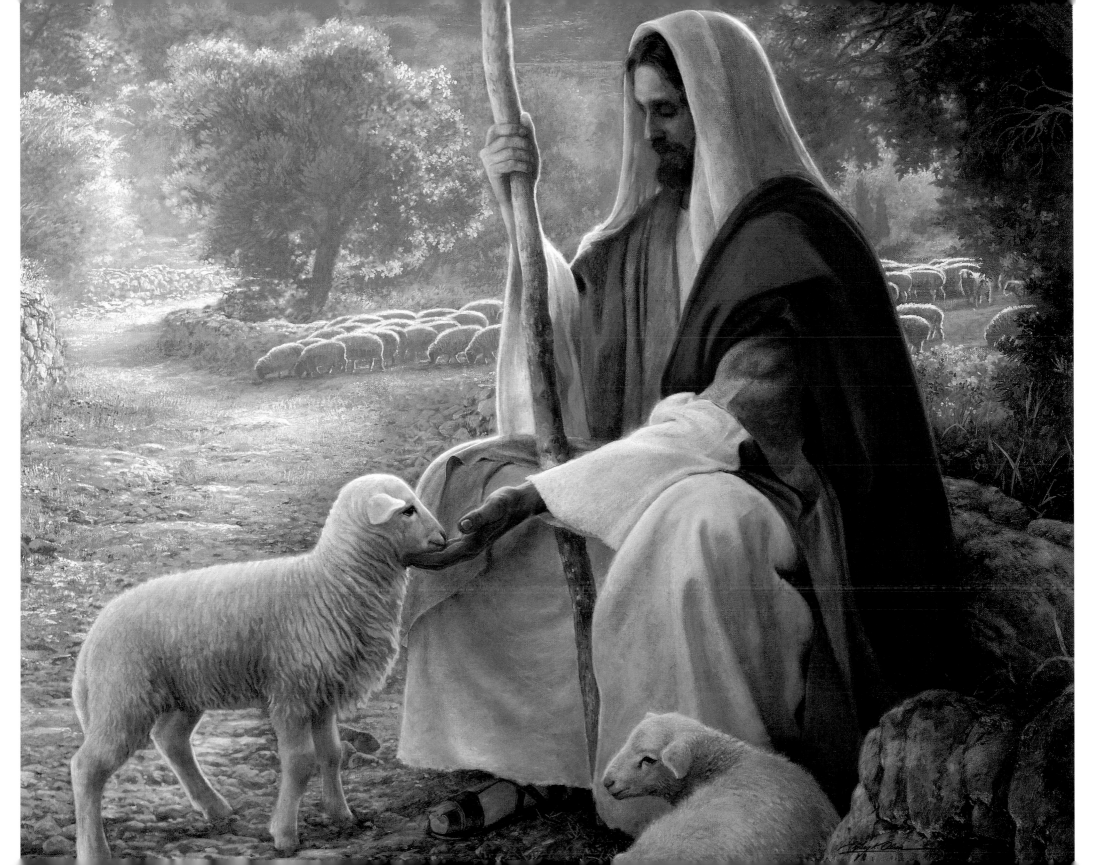

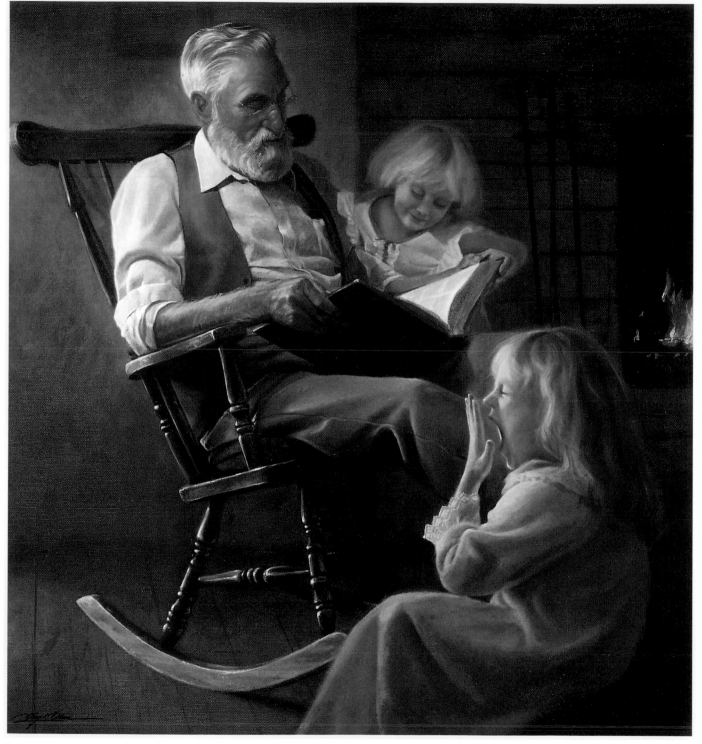

44

The Clockmaker

The hands of time seem to accelerate in their continuous revolutions. Before we know it, the seasons of our life change from one to another. Spring and summer are fleeting. Autumn comes and brings with it the realization that the days are moving faster and winter is soon to follow. Those winter days of life, however, bring an understanding and perspective that can lead us to the true joys and pleasures of life.

— GREG OLSEN —

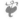

ABOVE: BEDTIME STORIES. RIGHT: THE CLOCKMAKER.

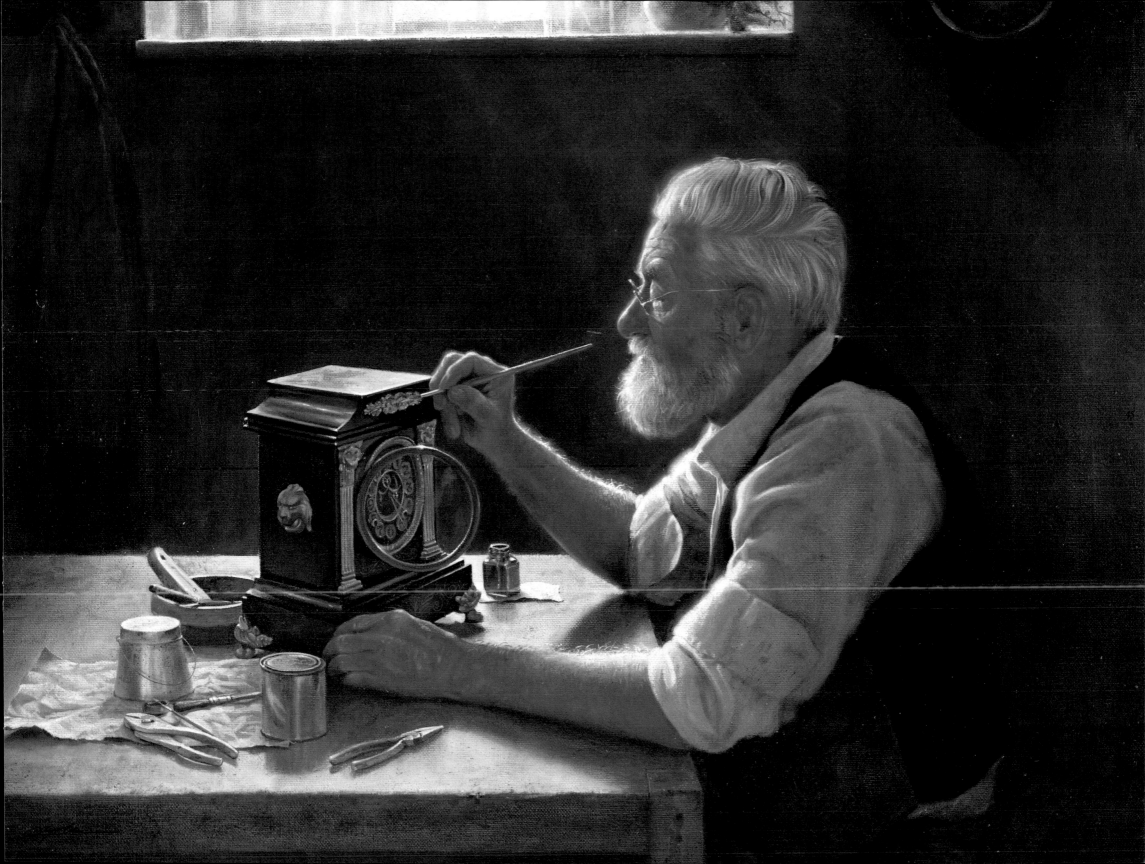

Wherever He Leads Me

Choosing to follow our Lord has never been the easiest path that one can take, in this or in any age. It means forgiving when we are tempted to be unkind, helping when it would be easier to turn away, and sometimes going it alone rather than going along with the crowd.

Jesus realized this, and when a scribe (a teacher of the law) said to Him, "Master, I will follow thee whithersoever thou goest," Jesus forewarned him. "The foxes have holes, and the birds of the air have nests; but the Son of man hath not where to lay his head" (Matthew 8:19–20).

History is filled with examples of those brave souls who sacrificed much for their beliefs. And while the true believer might not always find favor with his fellow man, he will find it in heaven, for our Lord also promised, "If any man serve me, let him follow me; and where I am, there shall also my servant be: if any man serve me, him will my Father honour" (John 12:26).

— Greg Olsen —

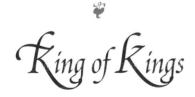

King of Kings

This image looks forward to the day when Christ will exchange His wooden staff for a royal scepter, when He will be seen as the Prince of Peace, Lord of Lords, and King of Kings.

He will rule, not as a vengeful dictator, but as one who said, "In my Father's house are many mansions . . . I go to prepare a place for you . . . that where I am, there ye may be also" (John 14:2–3).

— Greg Olsen —

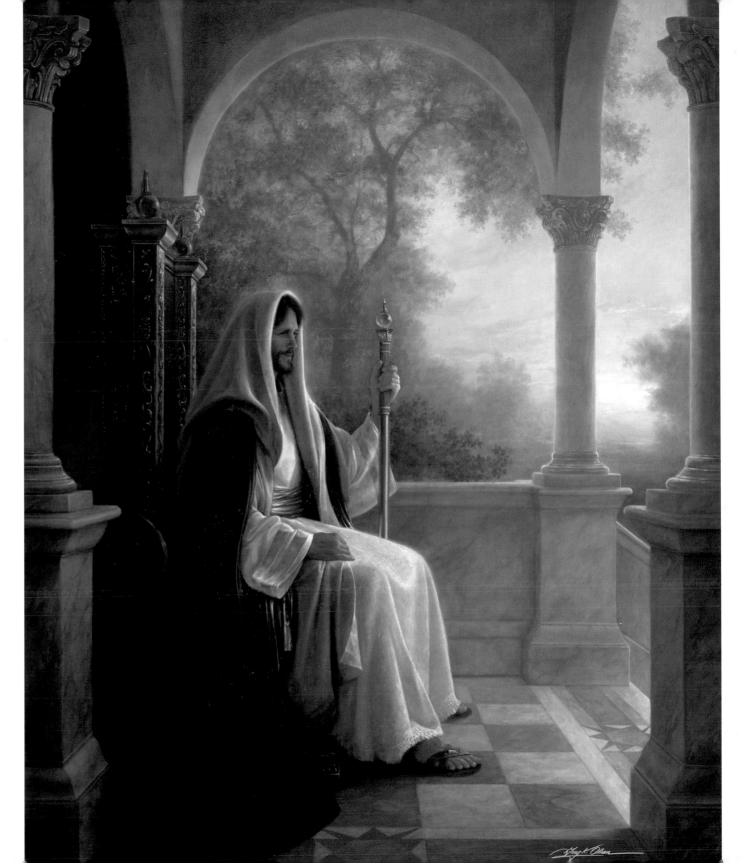

Trader at the Rendezvous

There always seems to be a facination with our past. A previous age always seems more romantic and interesting than the present one. We collect old things. We love to remember, reminisce and reenact. I used to love to ask my parents and grandparents to tell me about "the olden days." Now my children ask me the same thing!

— GREG OLSEN —

RIGHT: TRADER AT THE RENDEZVOUS.
OPPOSITE: RELICS OF A SNAKE RIVER TRAPPER.
BACKGROUND: CAMELBACK AT SUNDOWN.

48

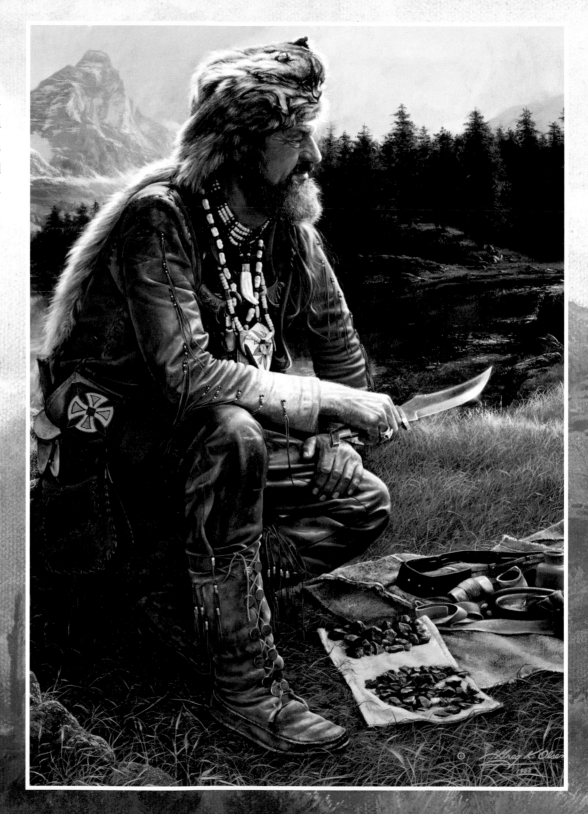

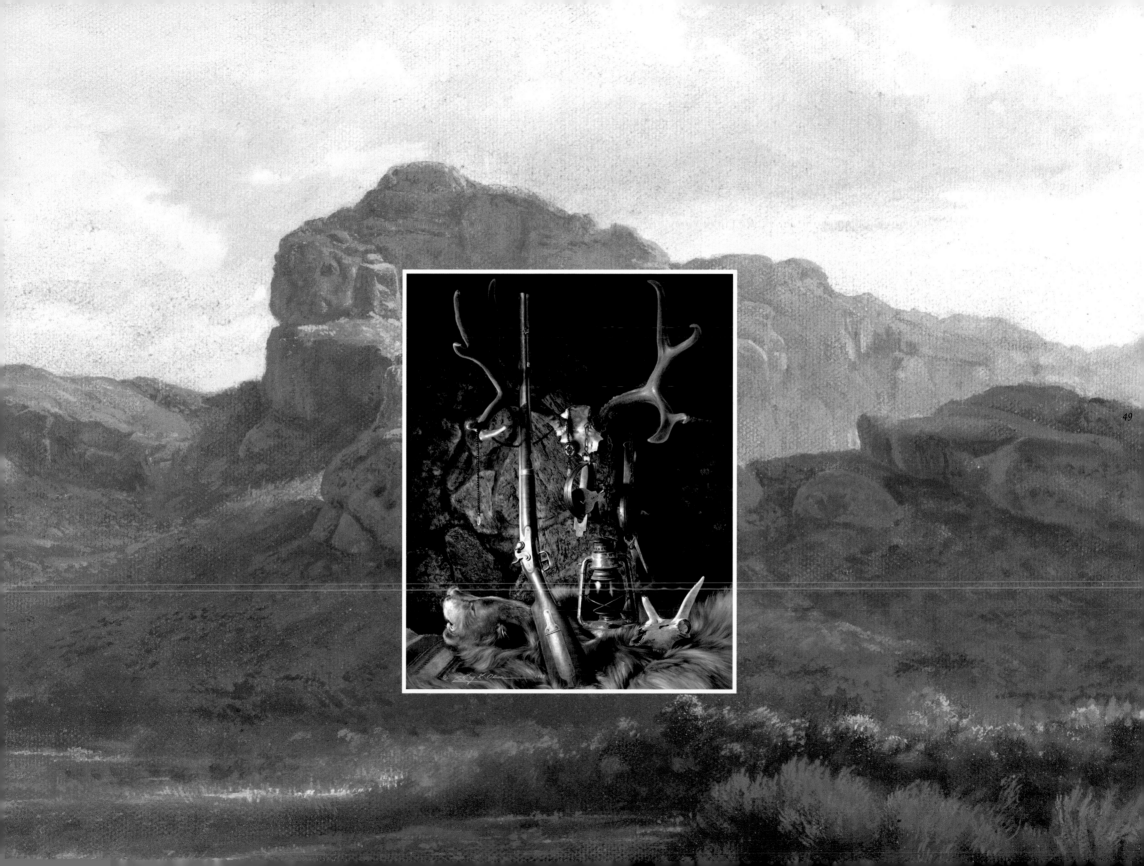

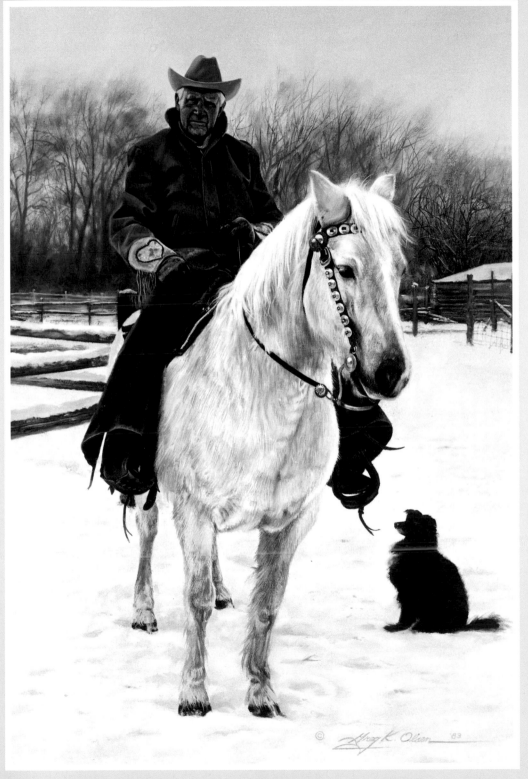

Tom Shurtliff

Many of my fondest memories center around my boyhood days growing up in the little farming community of Iona near Idaho Falls, Idaho. One of the permanent fixtures around Iona was old Tom Shurtliff. Tom was ninety-five years old at the time of this painting. Every morning he would ride his horse around town. At ninety-five, he could no longer stand on the ground and lift his foot into the stirrup to get into the saddle. He could, however, still climb up onto his rail fence. He would then whistle to his horse, which would come and stand alongside the fence so that Tom could cross over into the saddle. Where there's a will, there's a way!

— GREG OLSEN —

OPPOSITE: BOYHOOD WINTER. ABOVE: TOM SHURTLIFF—95 YEAR OLD COWBOY.

Light of the World

Just as a light set upon a hill serves as a beacon to weary travelers, so Jesus Christ stands as a shining example to all the world, showing us a better way to peace and happiness. His light illuminates the path of life, leading us along the straight and narrow way, exposing obstacles that may cause us to stumble, or forks in the road that might lead us astray. Those who press on, with their gaze fixed upon the light of Christ, have their own lights kindled within. Rather than merely casting a shadow, they serve as helpful luminaries to the rest of humanity on life's journey.

— GREG OLSEN —

52

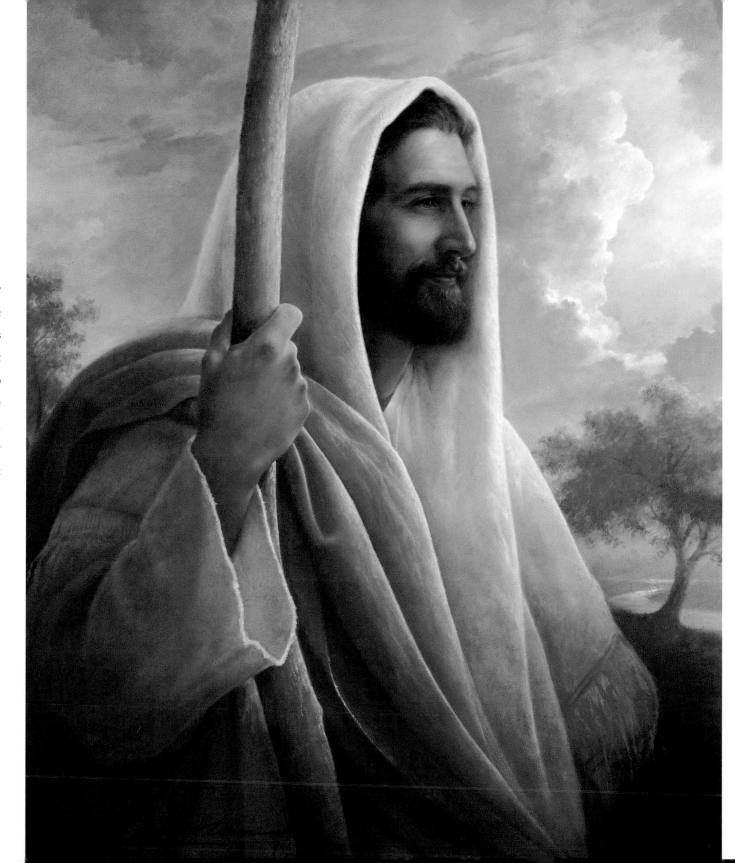

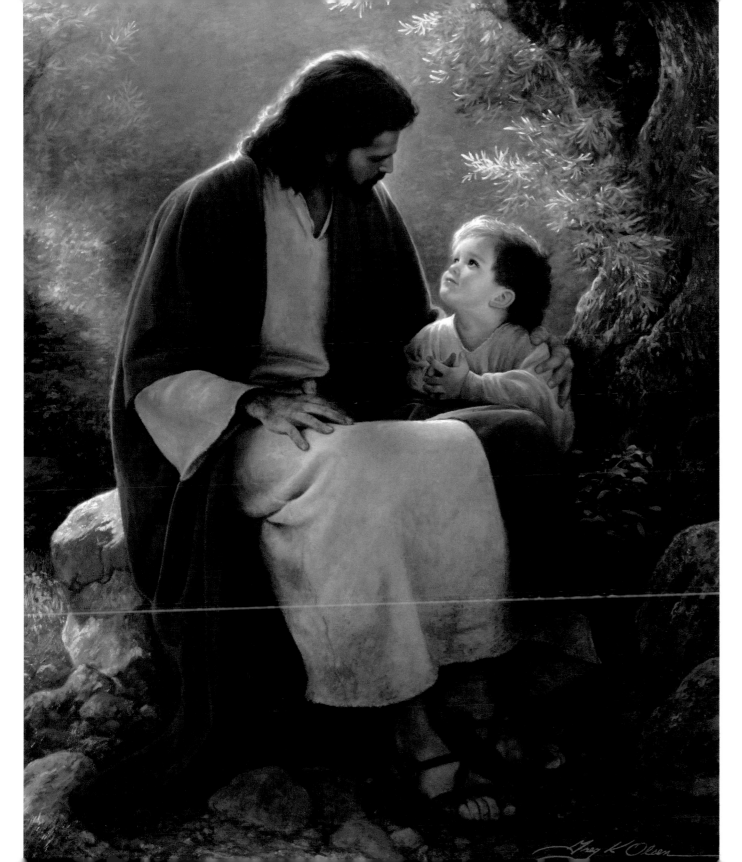

In His Light

Little children seem to have an inborn goodness; a simple faith and natural desire to be taught and to walk in His light. The light of Christ is given to each, and it shines in their faces. It is a light that shines in a helpful conscience that teaches of right and wrong. It is a light that illuminates their path when the way grows dark. And it is a light that warms their hearts and lets them know that they are loved and always in His light.

— GREG OLSEN —

53

Cream and Sugar

A splendid afternoon
having yummy cake and tea,
And lively conversation with
the finest friends that could ever be.

The chit, the chat about this and that,
the dresses trimmed with laces,
The bric-a-brac from the china rack
of the hostess ever gracious.

The tinkling and clinking
of the cups and silver spoons,
Add music to the perfumed air
and play a delicate tune.

Sweet cream and sugar bring back memories
of those younger days in June,
With yummy cake and tea
on a splendid afternoon.

— GREG OLSEN —

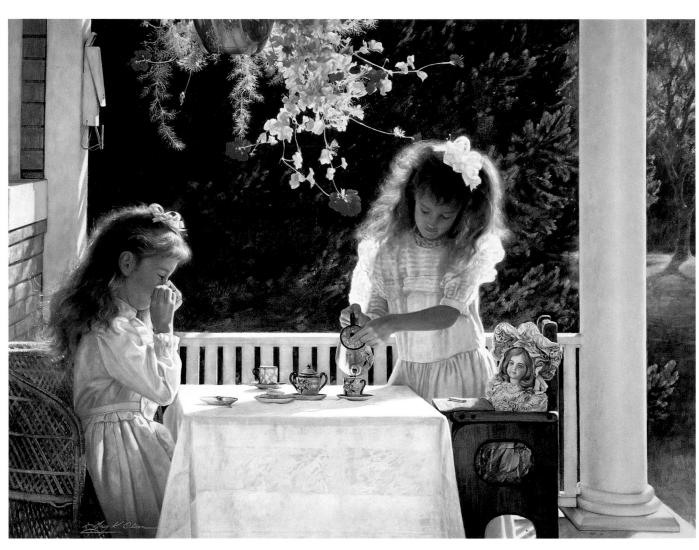

ABOVE: FRONT PORCH TEA PARTY. OPPOSITE: CREAM AND SUGAR.

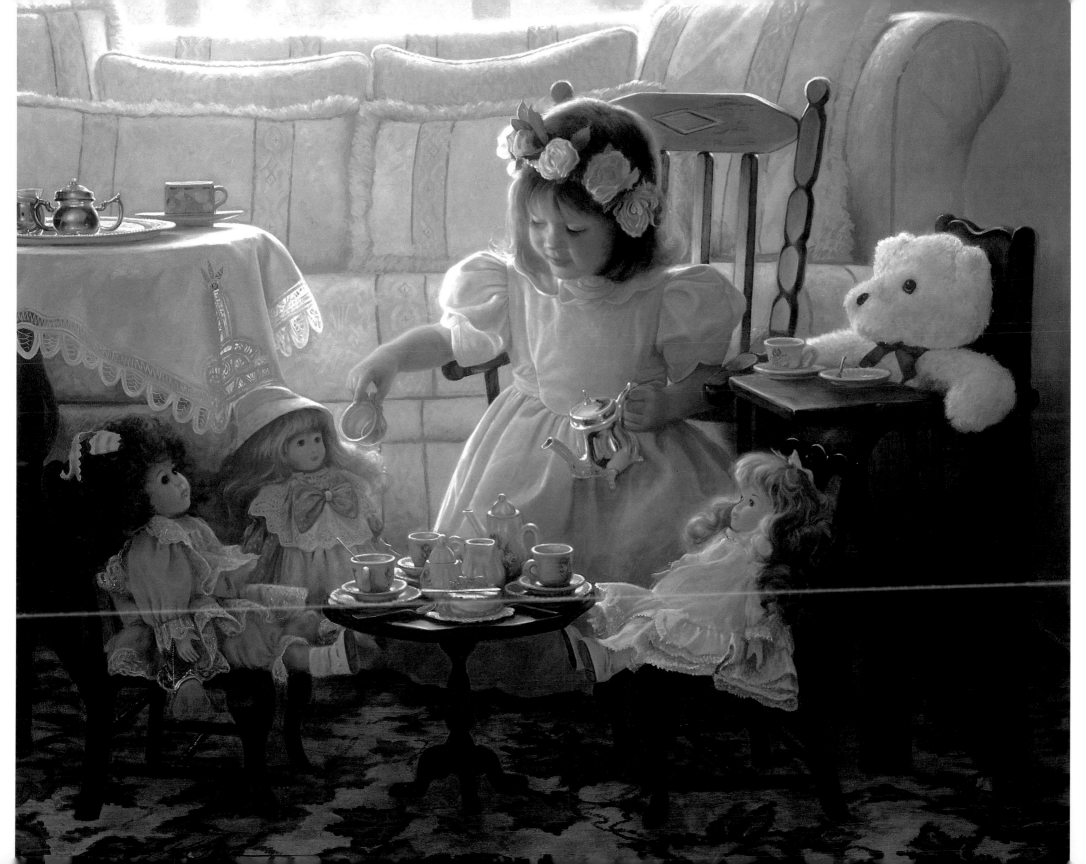

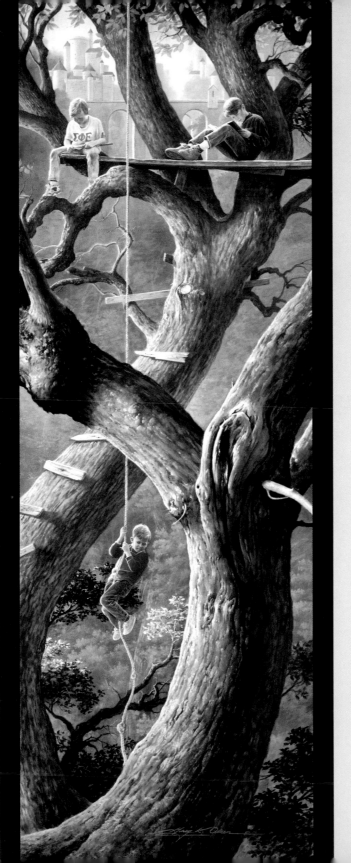

The Fraternity Tree

We certainly exalted it when we called it a "treehouse," that bunch of boards from Grandpa's scrap pile. It wasn't much more than a perch to ponder on, but to us it was our towering fortress, a lookout post over the kingdom which belongs to youth. Within the branches of that tree we felt invisible to earthbound eyes, the sun felt warm and calming, and loud-mouthed boys were quiet up there in our fraternity tree.

— GREG OLSEN —

Shruberbia

Whimsy, fantasy, wonderment, and imagination are powerful tonics. They can be elixers which increase our enjoyment and enthusiasm for living. They bring relief from the effects of taking things and ourselves too seriously. It is difficult to recall ever seeing a young imaginative child depressed and weighed down by the heavy mental burdens of life.

— GREG OLSEN —

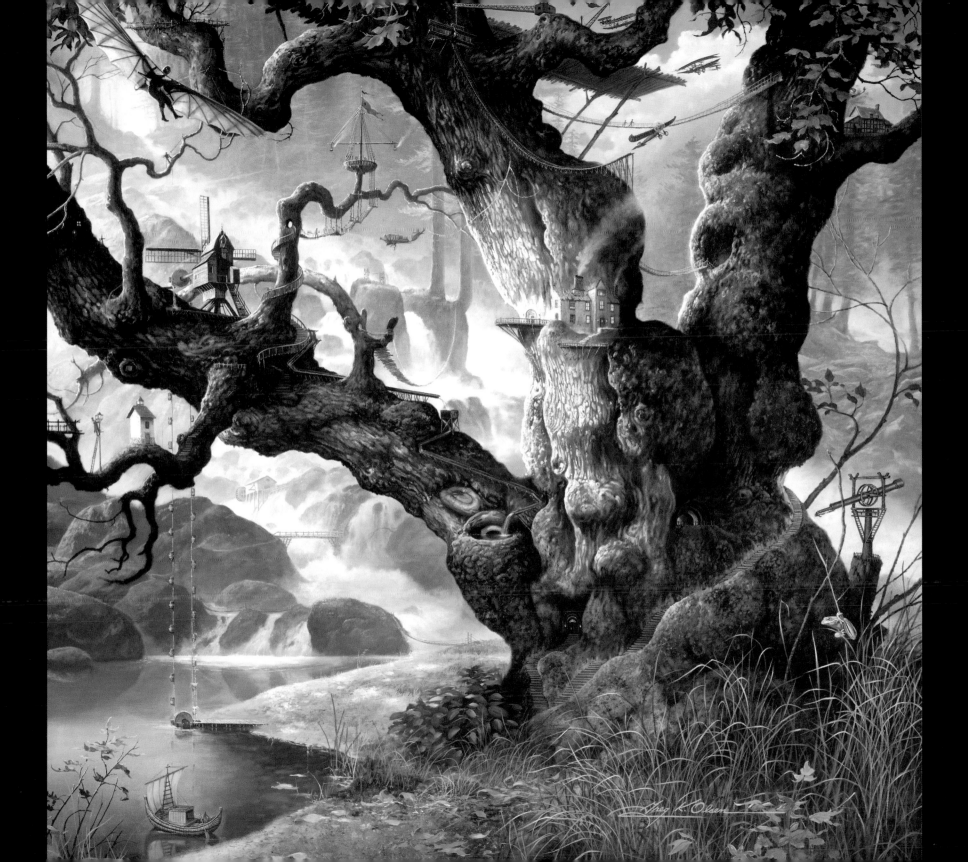

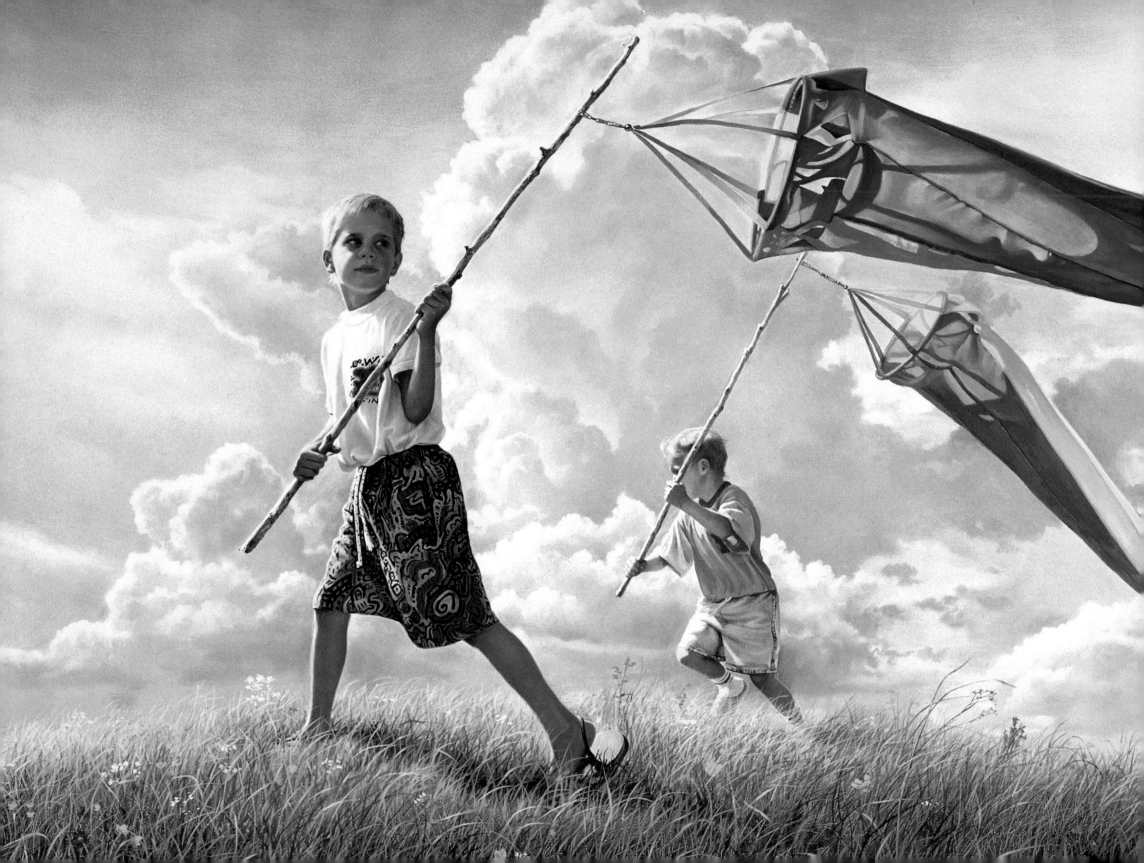

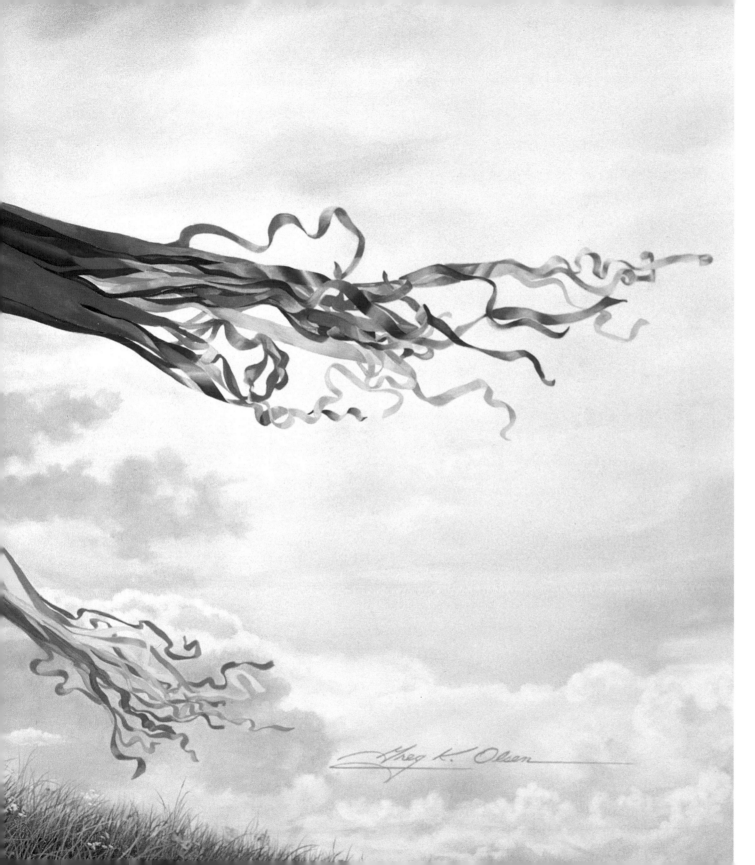

Wind Socks

Those carefree summer days of youth! How was it possible to squeeze so much into a single afternoon—let alone an entire summer! Perhaps it is because we lived so intensely, not by trying hard but by flowing with life naturally. We didn't live out of our daily planners or from our "do it lists" and yet we ironically seemed to have time to get a lot more done—including having fun!

— GREG OLSEN —

Fountains of My Youth

Fountains have long inspired thoughts of eternal youth and well-being. They have become a legendary site for registering those secret wishes of our hearts. Of course, we know that the fountain's powers are born purely of myth and fancy, and yet we are left to explain why it seems quite impossible, while splashing our bare feet in a fountain pool, to maintain any air of dignity or adult sophistication, or to keep at bay the wave of childish giddiness that floods over us. Why does some instinctive urge cause us to reach in our purse or pocket and cast our coins into the water and our wishes to the sky with all the hopefulness of a child?

Here at this fountain, within this villa garden, you can take your shoes off, cool your feet, cast your coins, and make your every wish come true.　— GREG OLSEN —

Formal Luncheon

So nice of you to invite me dear
Now what's the latest, I'm dying to hear.

How's your baby? She's such a doll!
Why, you've lost weight, you're so so small.

Love that outfit, it's just divine,
I adore your hat—do you like mine?

This food looks lovely, you never fail,
Oops! I must get a manicure—I think I just broke a nail!

Well thanks so much, I've been glad,
For this formal luncheon we have had.

Yes, we must do this again—and very soon,
You say how about tomorrow promptly at noon?

Sorry I'm busy tomorrow—you know, schedule crunch,
How about next week, let's do lunch!

— GREG OLSEN —

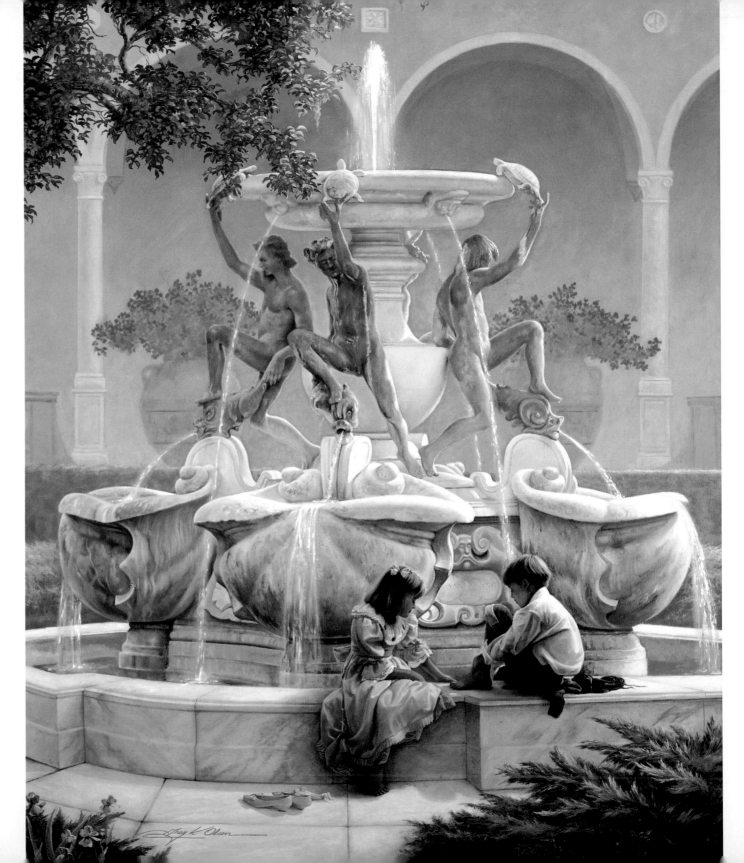

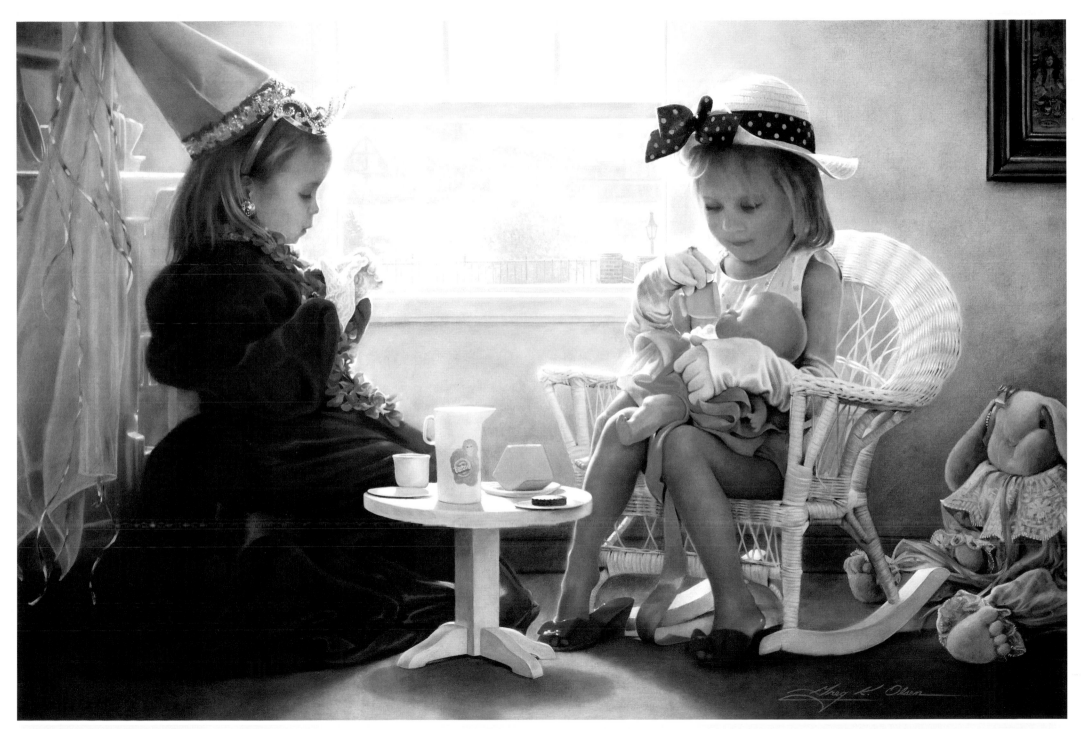

61

OPPOSITE: FOUNTAINS OF MY YOUTH. ABOVE: FORMAL LUNCHEON.

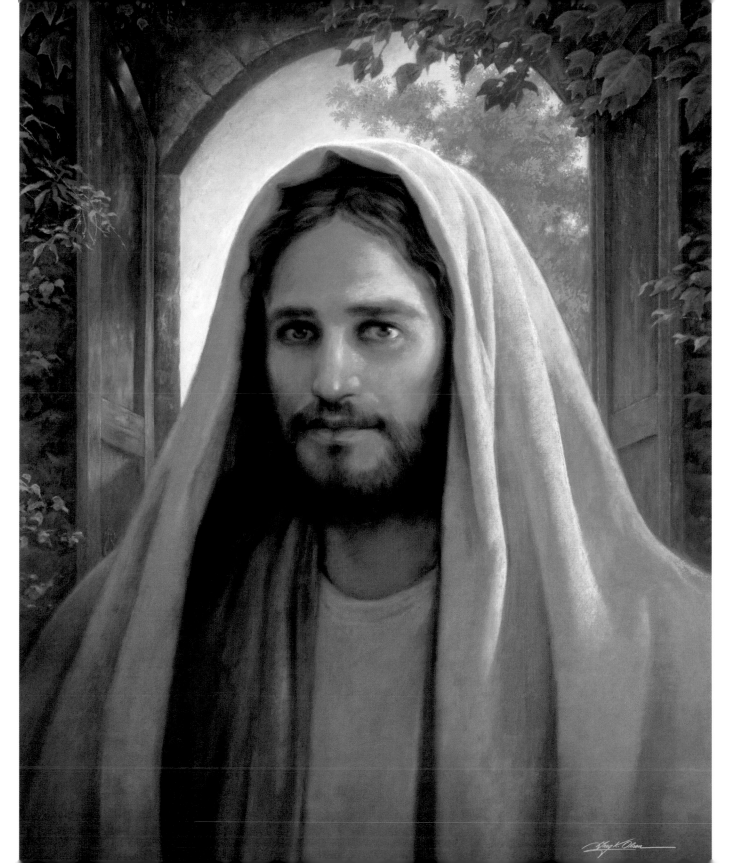

Keeper of the Gate

Christ is portrayed here as the keeper of the gate; the One we must pass by to enter into our heavenly rest.

His eyes seem to follow the viewer. His piercing gaze is direct, looking right into our eyes and seeing every nook and cranny of our souls. This is Someone we can't escape or deceive. His frame actually blocks the gateway through which we must pass, so much so that the part of the gate which is visible appears as perhaps merely a window. Only when He steps aside and invites us in will the full picture come into view.

If the viewer looks a bit closer, the Savior's stern gaze will give way as we notice eyes that are moist and tender, and we discover a hint of a smile upon His face. These subtle signs reveal His true nature and His patient love for those struggling to find and reach the gate. The Keeper's greatest role is as One who welcomes, encourages, and lights the way. He opens wide the doors to all who knock and truly come unto Him. For He said, "I am the way, the truth, and the life: no man cometh unto the Father, but by me" (John 14:6).

— GREG OLSEN —

In His Constant Care

Perhaps no other being in history has been the subject of more artwork than has Christ. Artistic masters throughout the ages have been drawn to the challenge of portraying themes of inspiration and significance. The life of Christ is an enduring model of humility, compassion, and love.

This painting is a visual reminder of one of His most comforting messages regarding the worth of each individual soul. "Are not five sparrows sold for two farthings, and not one of them is forgotten before God? But even the very hairs of your head are all numbered. Fear not therefore: ye are of more value than many sparrows" (Luke 12:6–7).

As I look at the intricate design of these little sparrows, experience tells me that where there is a design, there is a designer! It is a comforting thought to consider that somewhere there is a Creator who is aware of and has love for even the least of His creations. There is incredible intimacy in the vastness of this thought.

— GREG OLSEN —

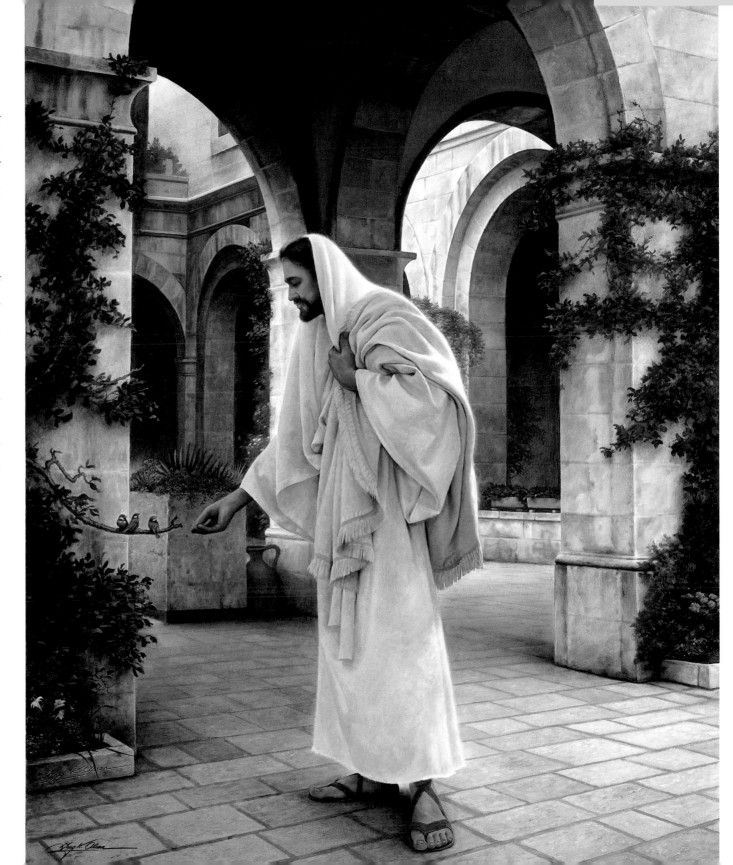

63

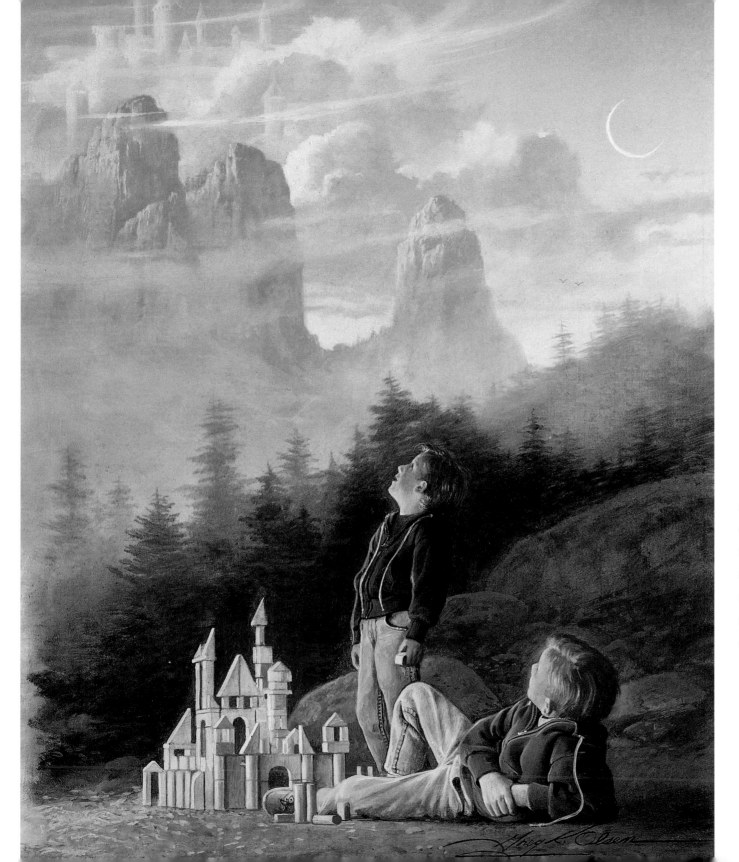

Looking Up

I sometimes look for castles way up in the sky,
And think of how I'd get there if only I could fly.
Soaring through the clouds with the earth so far below
What's it like to live there? Someday I think we'll know!

— GREG OLSEN —

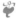

I Love New Yorkies

I Love New Yorkies is a celebration of childhood and the newness of life. The morning light signals the beginning of a new day, and the scent of fresh spring flowers announces the arrival of a new season. Excitement, adventure, and wonder are represented in the posture of the pups. The child reminds us of the barefoot days of youth when nothing mattered except the here and now, when the cares of the world were years away, and joy came from the simplest of things.

— GREG OLSEN —

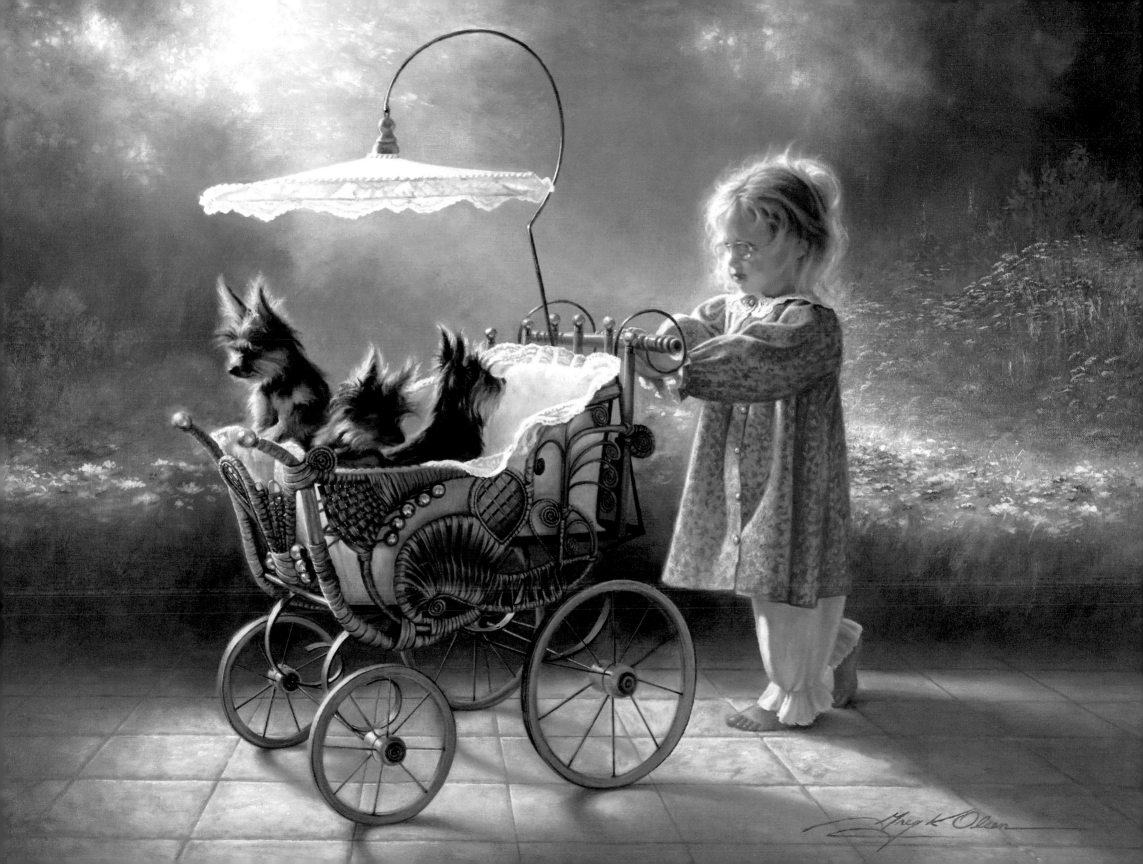

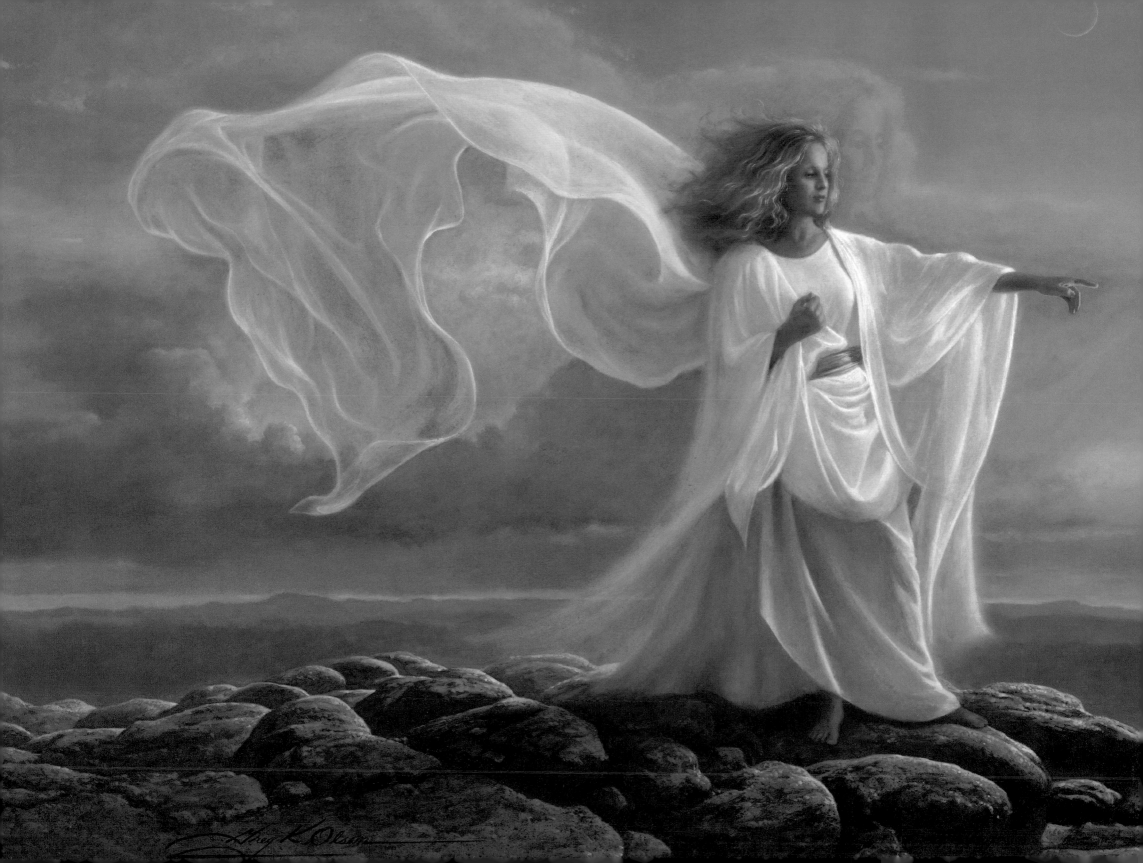

The Messenger

Often, there are times in life when we go through difficult periods, times when we feel as though we're wandering in the wilderness—seeking direction, solace, and answers. And often, during those trying times, if we allow ourselves, it is as though we receive a subtle signal in the form of some small wonder.

It may be something as simple as turning on the radio and at that very moment, hearing the lyrics of just the right song, or opening the scriptures to a verse with poignant meaning, or even having a little songbird land nearby to cheer us up. These are some of the small things that have helped me along at such times, causing me to look heavenward, smile, and say a quiet, "Thank You!"

During a time in my life in which I had an important decision to make, I was trying to sort out my thoughts while hiking. As I looked out over the horizon, I noticed that the billowing clouds resembled a figure that seemed to me to point the way that I should choose. And while I know they were only clouds, like an angelic messenger sent to one needing help along the way, they were just as beneficial as all the other small wonders that I've experienced when I needed them most.

"Bless the Lord, O my soul . . . who maketh the clouds his chariot: who walketh upon the wings of the wind: who maketh his angels spirits . . ." (Psalms 104:1, 3–4).

— GREG OLSEN —

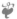

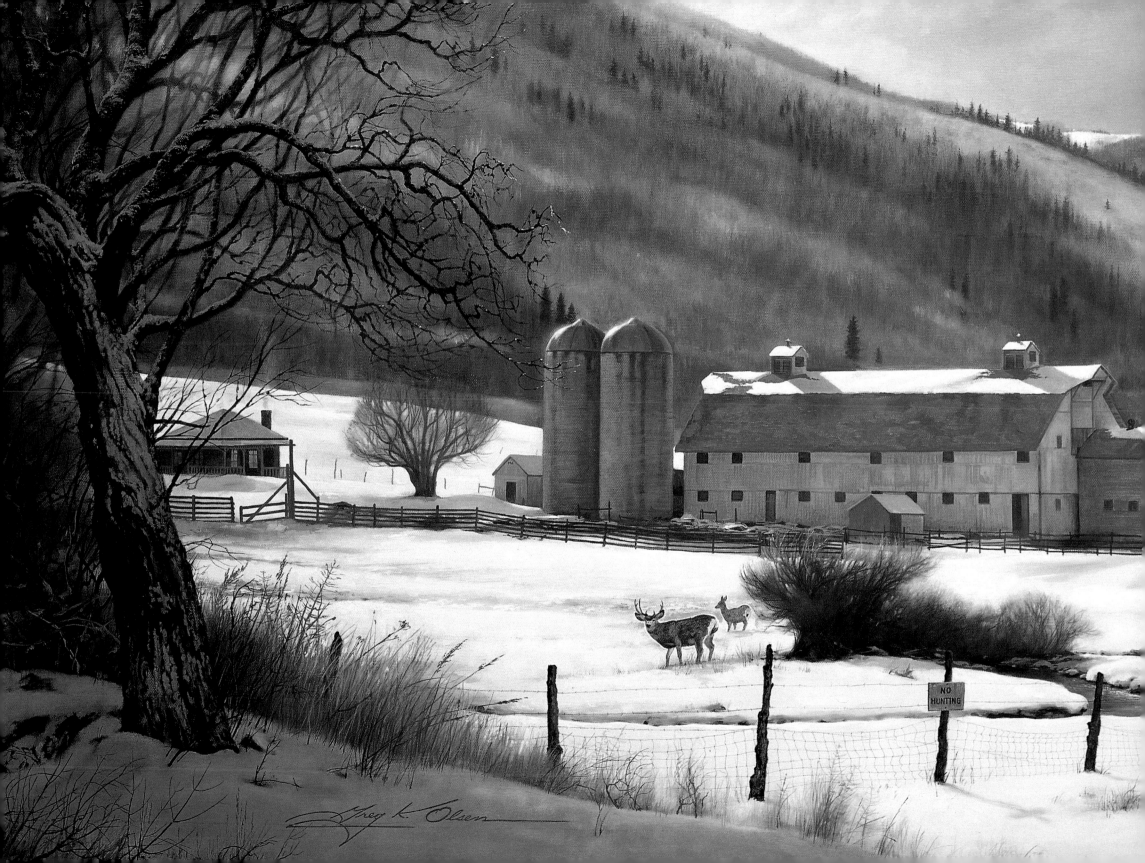

NO
HUNTING

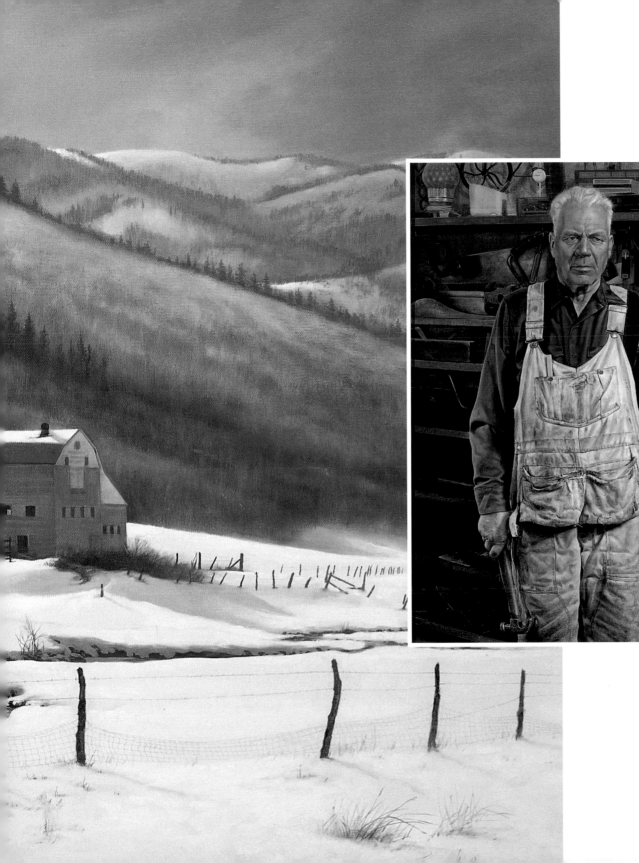

The Tradesman

Years ago I worked in a studio built by this man A.R. Barton. He built the studio for his wife, Bernetta, who began painting in her 60's. At the time, the only studio of my own was half of our baby's bedroom. The Bartons were neighbors and offered their studio as a place for me to work—rent free! They were a great blessing to me and my family.

— GREG OLSEN —

Park City Barn

Even though it is winter, this painting reminds me of how the "grass is always greener on the other side of the fence." A prize buck is just on the other side of a fence on which is posted a discouraging "NO HUNTING" sign.

— GREG OLSEN —

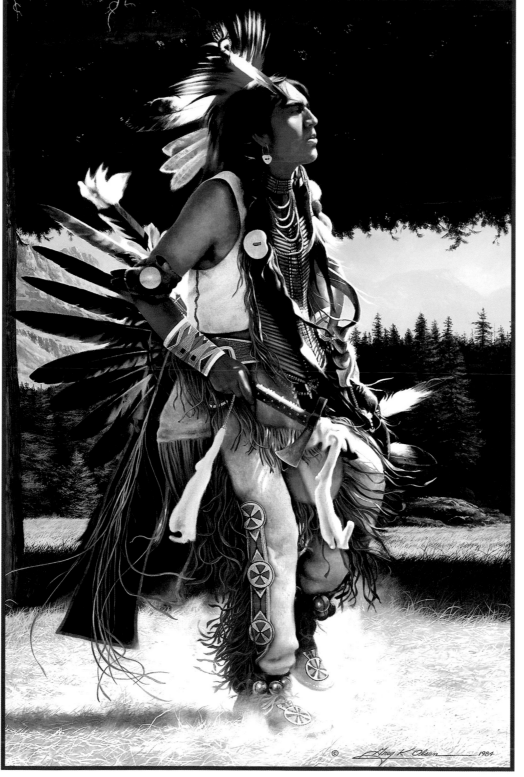

70

Great, Great Grandson of Geronimo

I met this noble Native American at a rendezvous in Fort Bridger, Wyoming. Morgan Maize is his name, and I was thrilled to have him pose in this beautiful headdress. I found out later that Morgan is a Chiricahua Apache and is actually the great, great grandson of Geronimo. Who knows? Maybe our family roots hold a fascinating story for each of us.

— GREG OLSEN —

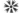

ABOVE: DANCE OF HIS FATHERS. OPPOSITE: GREAT, GREAT GRANDSON OF GERONIMO.

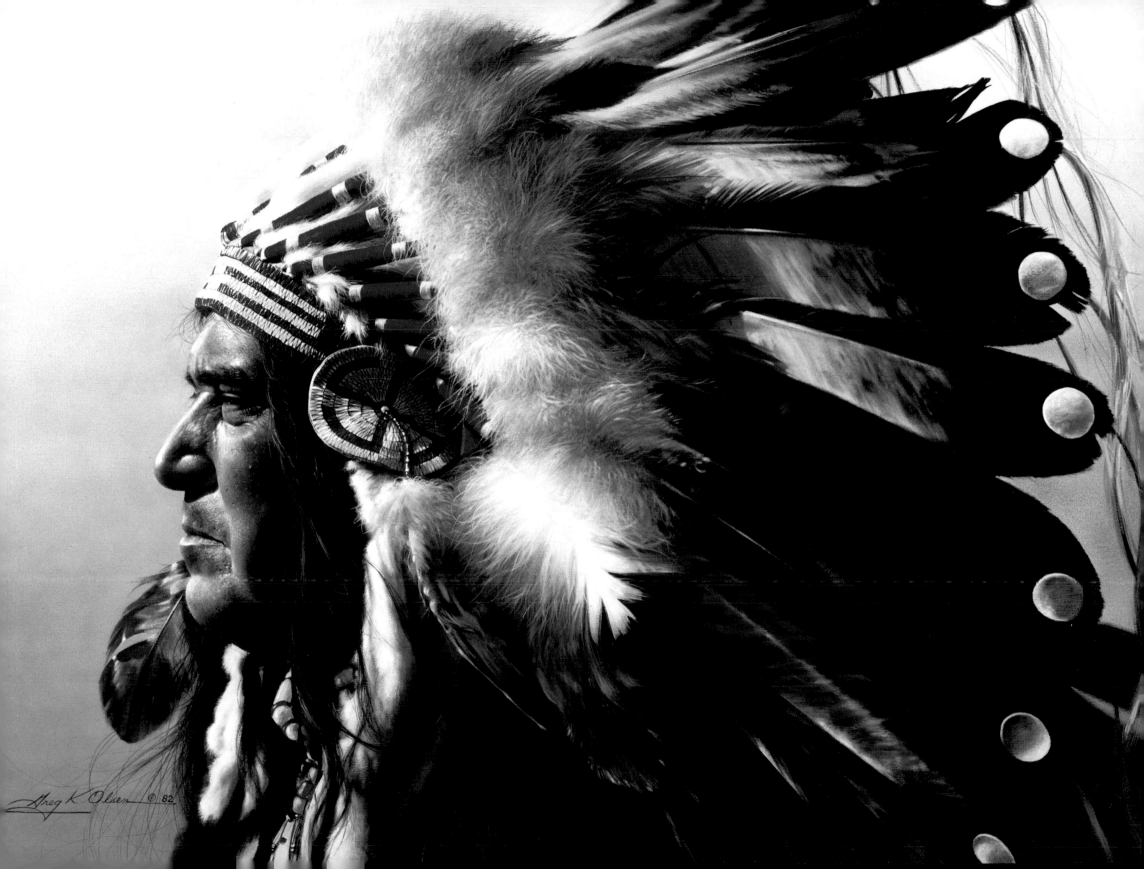

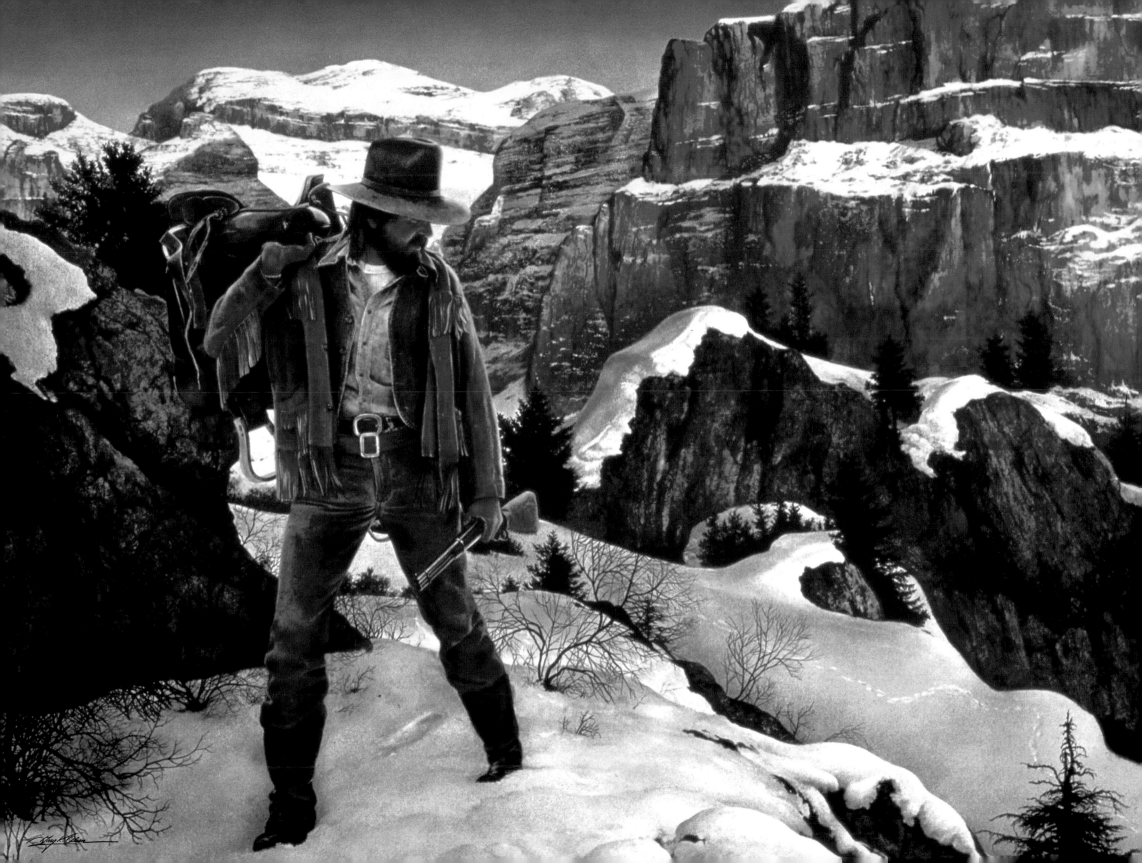

A Good Horse Gone

This painting illustrates the story of a rider whose horse fell and broke its leg. Out of love for his horse, he does what he feels is most merciful and puts the horse out of its misery. Kindness, love, and mercy sometimes come in disguised forms.

— Greg Olsen —

The Cattle Drive

There is a certain satisfaction and contentment that comes from a long day's work, especially outdoors. The day can start before sunup and go until sundown. At the end of the day your clothes can be dusty, your hands can be dirty, your arms can be tired, and your back can ache. Nevertheless, there comes a feeling of accomplishment and well-being that keeps you willing to get up and do it all over again tomorrow!

— Greg Olsen —

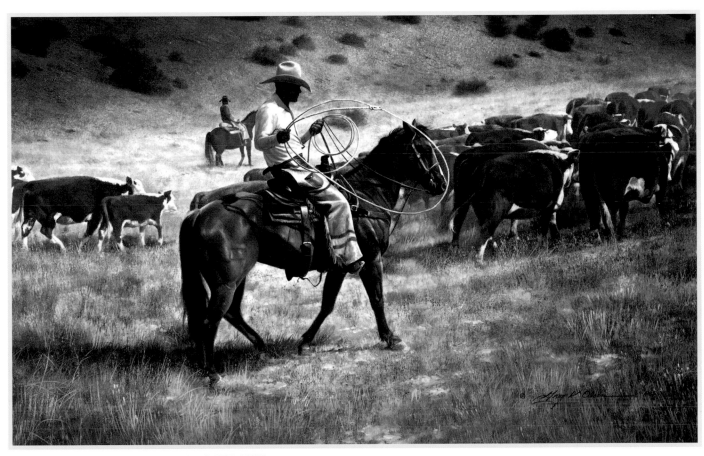

73

OPPOSITE: A GOOD HORSE GONE. ABOVE: THE CATTLE DRIVE.

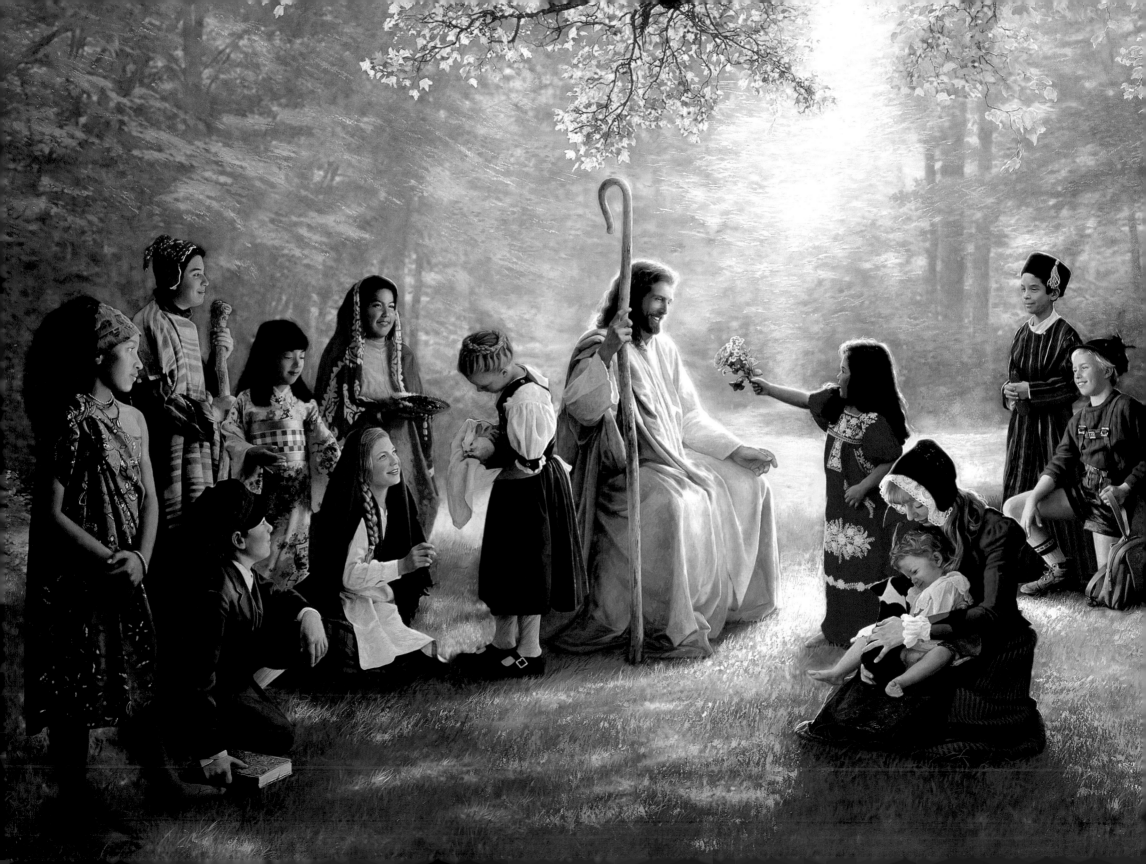

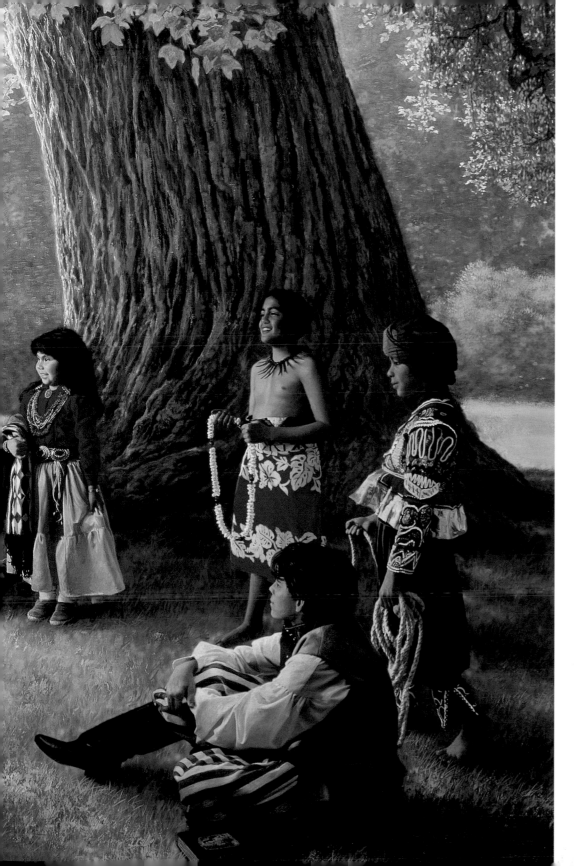

Children of the World

As the Good Shepherd, Christ proclaimed, ". . . other sheep I have, which are not of this fold: them also I must bring, and they shall hear my voice; and there shall be one fold, and one shepherd" (John 10:16). As the Savior of the world, Christ will gather all nations, and He will dwell in the midst of them. (Joel 3:2; Zechariah 2:11; John 11:52.) At the dawn of a new millennium, we look forward to that wonderful day.

The invitation to come unto Him is still extended to all the world. The scriptural admonition to become as a little child and to "walk as children of light" is meant to help us to prepare for that joyful time. (Matthew 18:3; Ephesians 5:8.)

Christ Himself came into this world as an innocent child, and children are especially beloved by our Lord. In *Children of the World*, we see the purity, innocence, and love that will prevail in a new era of peace and happiness, when The Good Shepherd returns to gather us together and dwell in our midst. — GREG OLSEN —

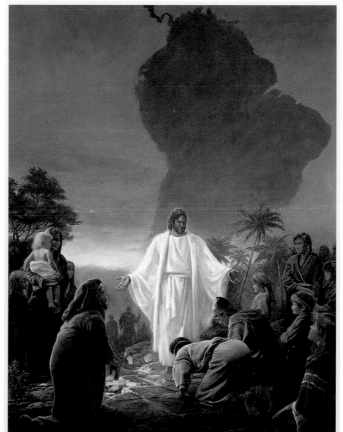

The Bible and the Book of Mormon Testify of Christ

Surely the Savior loved the people living in the Americas just as He loved those living in the Old World. Here, He is represented visiting some of His other sheep—the people of the ancient Americas.

— GREG OLSEN —

Rainy Day Off Jaffa Street

A trip to the Holy Land with my wife in 1988 was not only the inspiration for many Biblical paintings, but also provided wonderful insight into a modern-day culture steeped in tradition and rich in diversity.

— GREG OLSEN —

Prayer for Peace

Grant us peace, Thy most precious gift, O thou eternal source of peace, and enable Israel to be its messenger unto the peoples of the earth. Bless our country that it may ever be a stronghold of peace, and its advocate in the council of nations. May contentment reign within its borders, health and happiness within its homes. Strengthen the bonds of friendship and fellowship among all the inhabitants of our land. Plant virtue in every soul, and may the love of Thy name hallow every home and every heart. Praised be Thou, O Lord, Giver of Peace.

— PART I, 1940; PART II, 1942 OF THE UNION PRAYERBOOK —

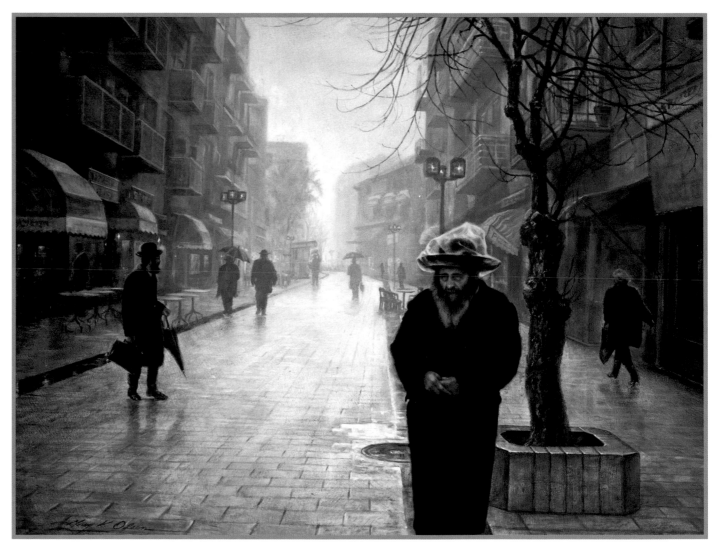

ABOVE: RAINY DAY OFF JAFFA STREET. OPPOSITE: PRAYER FOR PEACE.

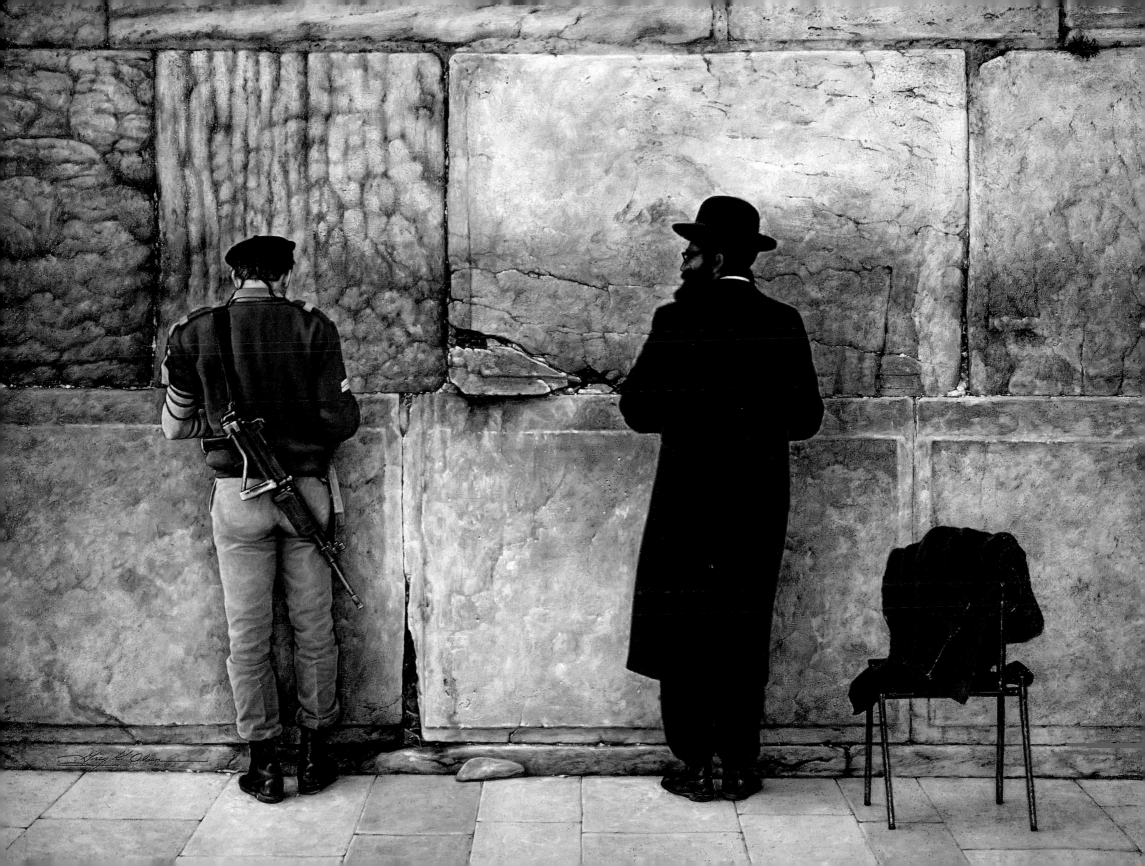

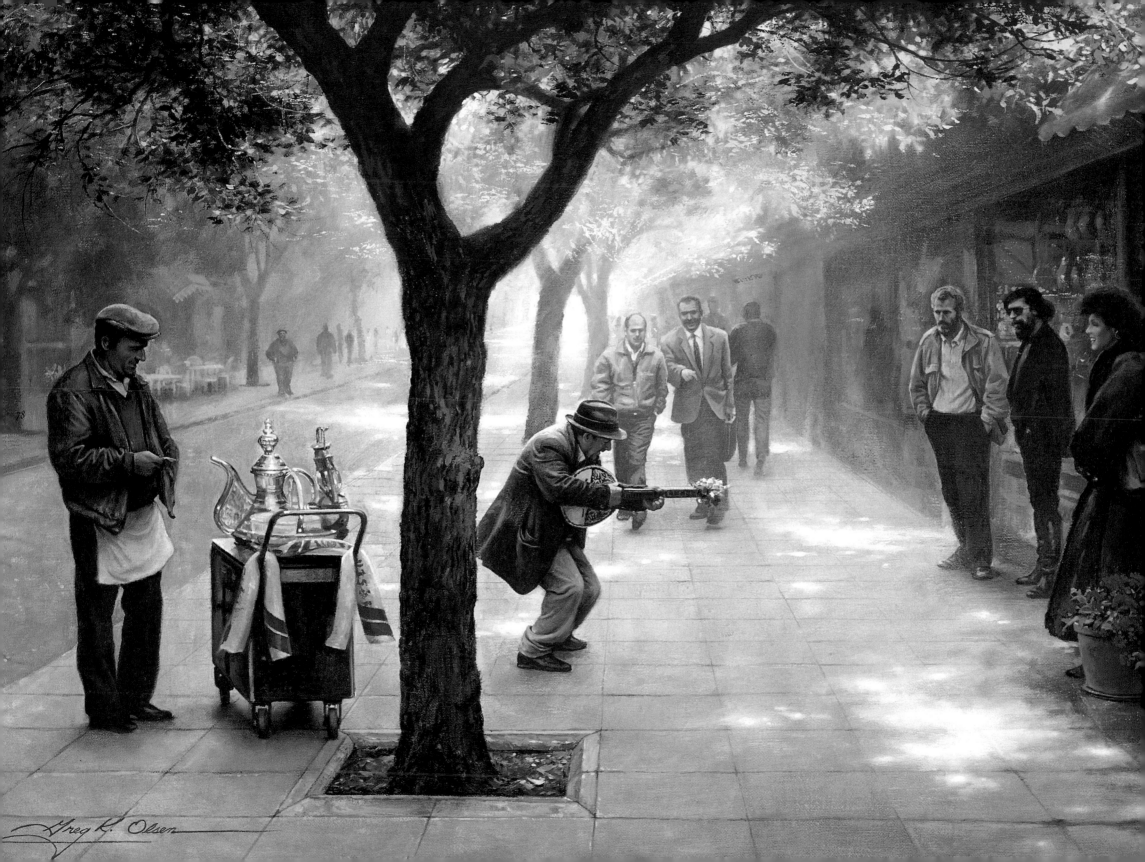

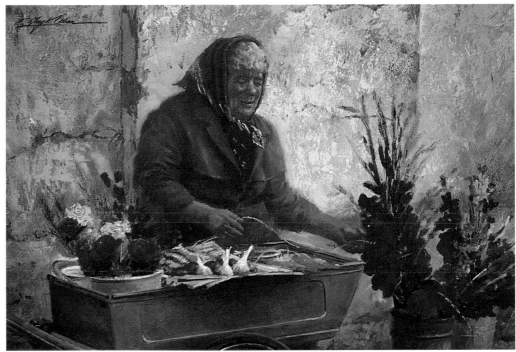

ABOVE: THE RUSSIAN FLOWER VENDOR. RIGHT: THE SIDEWALK PERFORMANCE.

The Sidewalk Performance

Travel has provided me with some of my richest experiences and most memorable education. Walking the streets of cities and towns in distant parts of the world has emphasized a pleasant paradox—we are all so unique, and yet in so many fundamental ways, we are all the same.

— GREG OLSEN —

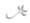

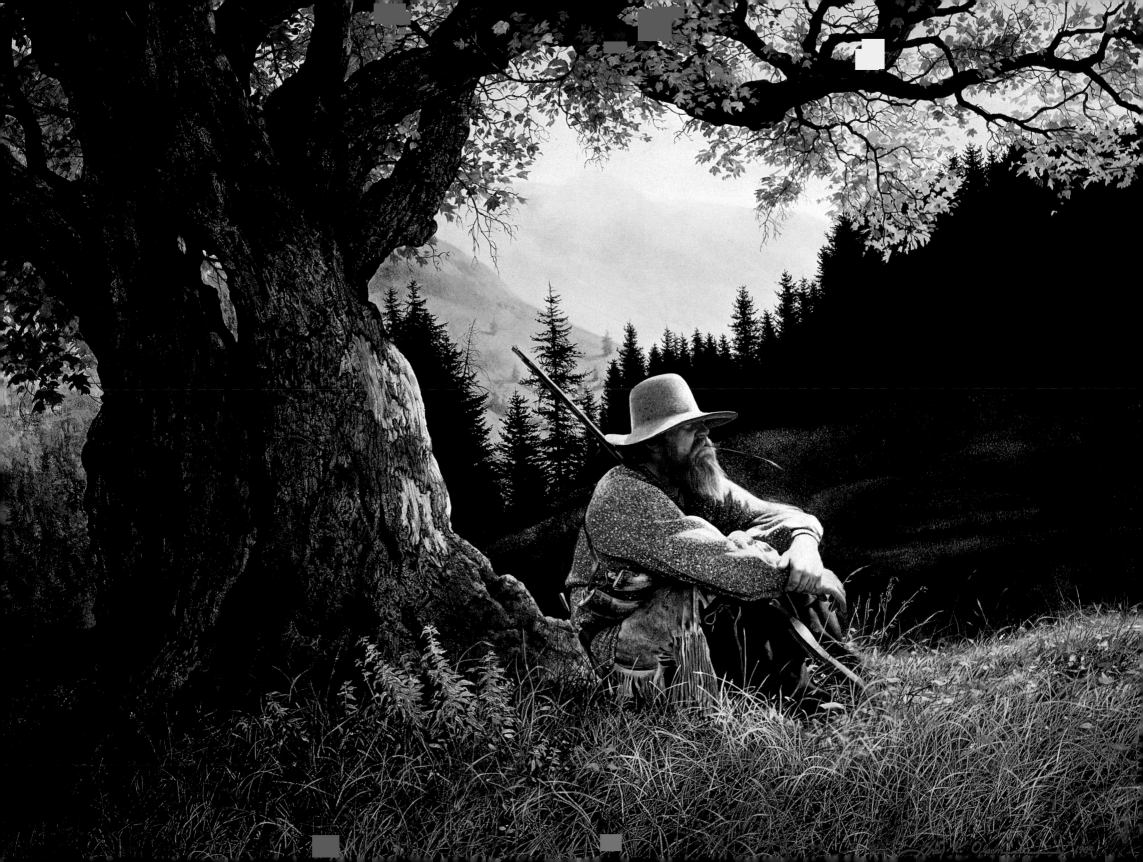

The Thinking Tree

We've all heard the phrase, "sometime I sits and thinks and sometimes I just sits!" There seems to be a therapeutic value in finding a quiet place to be alone with your thoughts—as the scriptures say to "be still and know that I am God" (D&C 101:16).

— GREG OLSEN —

Mind Riders

These cowboys are demonstrating the "act as if" principle—the power of mental imagery and visualization. Each of these men mentally visualized their ride as if they were actually on the horse—even whooping and hollering! It may look humorous, but it's effective. The cowboy in the purple shirt later went out and won the saddle bronc riding event.

— GREG OLSEN —

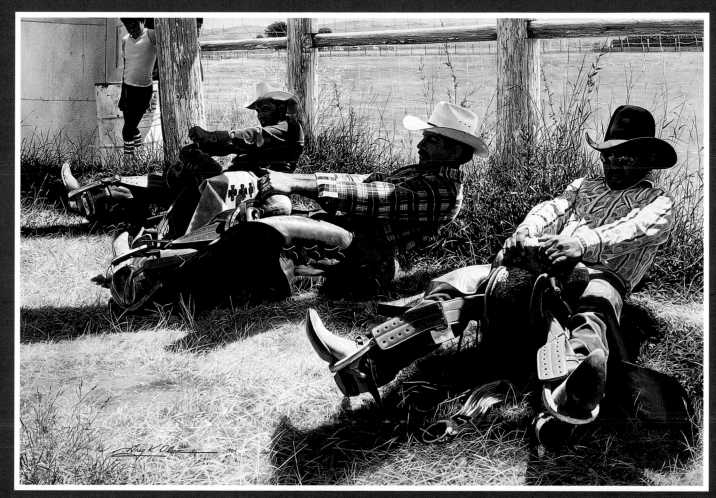

81

OPPOSITE: THE THINKING TREE. ABOVE: MIND RIDERS.

After the Masquerade

The masquerade here refers to the fleeting disguise of youth and of temporal beauty and worth. The young woman sits and ponders her own journey through the masquerade of life. Like the bouquet of flowers, her physical beauty is in full bloom for all to admire, but soon those things that are pleasing only to the physical senses shrivel and fade away.

If these earthly things shall all pass away, then placing undue value and importance on them is as foolish as believing that the activities of a masquerade or a carnival have some enduring importance in our lives.

Discovering the grand illusion of such temporal things need not be discouraging, depressing, or disappointing—far from it! Observe the young woman. Her eyes are closed and yet she is beginning to see with her spiritual eyes. She is awakening to a new vision of things as they really are. She sees that "real life" goes beyond the superficial and transcends the material world. That clear and uncluttered sight begins to bring a wonderful kind of rest and repose. A peaceful smile begins to cross her face—the masquerade is over!

— GREG OLSEN —

Sydnie

Surely woman is God's greatest masterpiece! She has inspired mortal artists throughout the ages. The painter's representation on canvas or the form cut by a sculptor in stone is but a feeble attempt to imitate what is already a work of art. That is how I felt while painting my favorite model and best friend—my wife, Sydnie!

— GREG OLSEN —

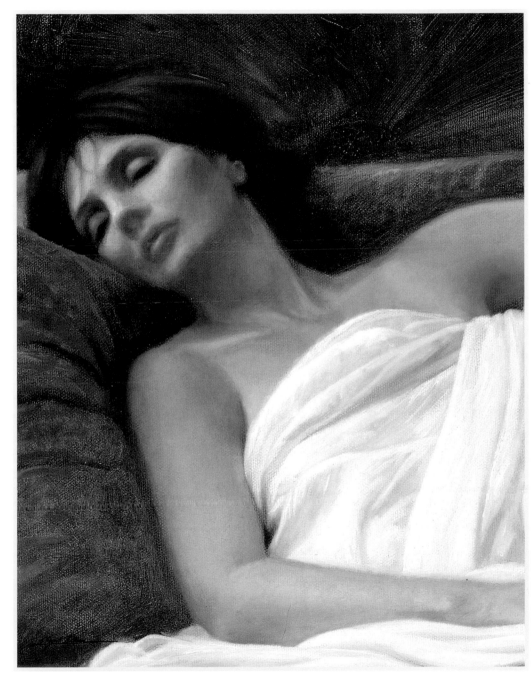

83

OPPOSITE: AFTER THE MASQUERADE. ABOVE: SYDNIE.

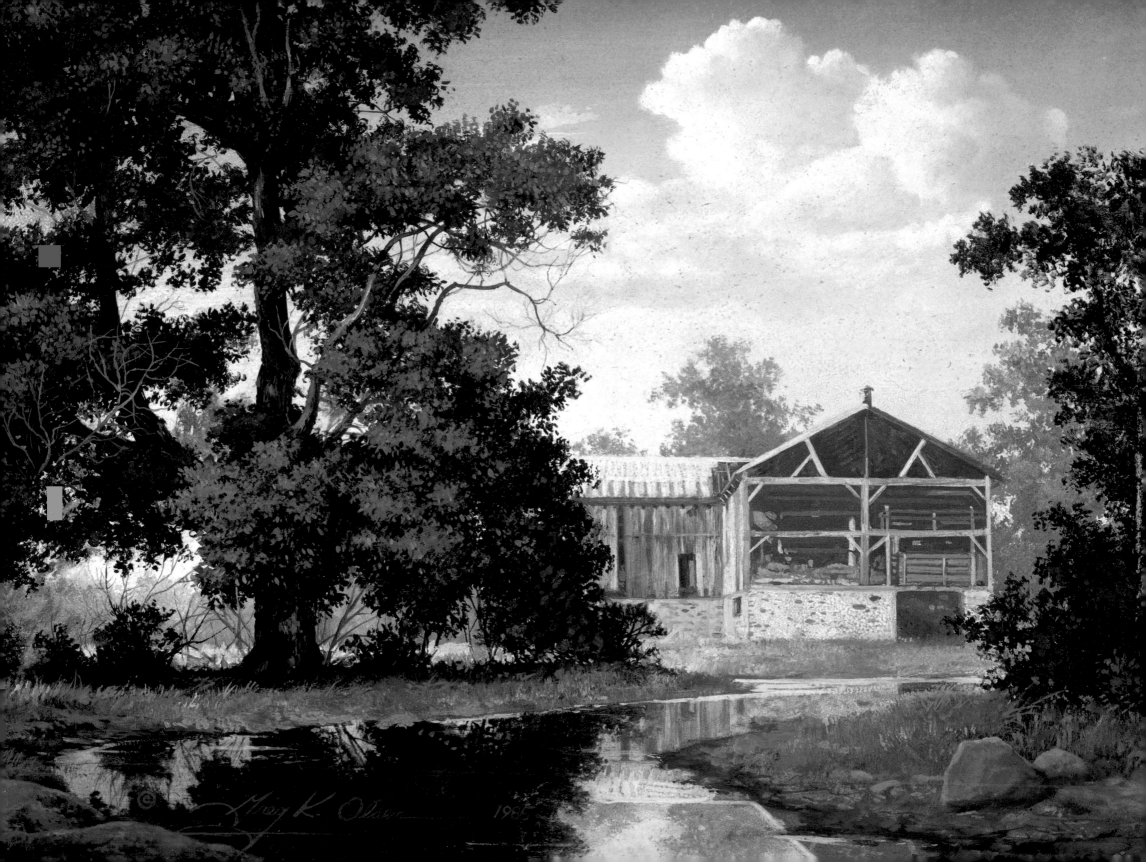

The Great Outdoors

I love to take time on a regular basis to get out into the rural farmland or the mountain back country to walk where my feet actually touch Mother Earth and not just wall to wall carpeting or the sidewalk. I like to kick some real dirt and smell things you miss out on when you're always indoors. I like to look at rocks and trees and wonder how long they've been there. I like to climb hills and look down at villages or valleys below. I like to let the sun shine on me and think. After one of these little excursions I always return refreshed with a little better perspective on things. My old surroundings are seen in a fresh new light and I feel somehow reoriented. I see more clearly where I'm at in relationship to the rest of the world. Funny how I'm not at the center of it after all!

— GREG OLSEN —

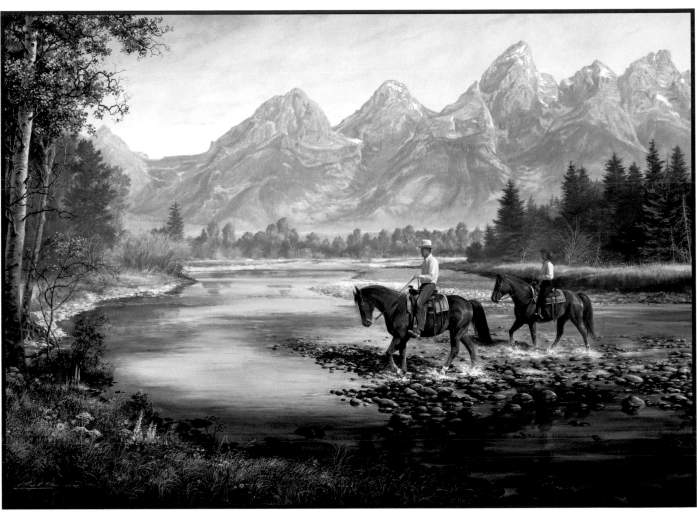

85

OPPOSITE: ONTARIO FARM. ABOVE: RIDING THE TETON RANGE.

Christ Raising the Daughter of Jairus

I can only imagine the gratitude a parent would have for the Savior as He restored the gift of life to their child. (See Matthew 9:18–19, 23–25; Mark 5:22–24, 35–43; Luke 8:41–42,, 49–56.) Our gratitude increases as we realize that He has actually given that gift to each and every one of us. Because of Jesus Christ, all of us will live again!

— GREG OLSEN —

86

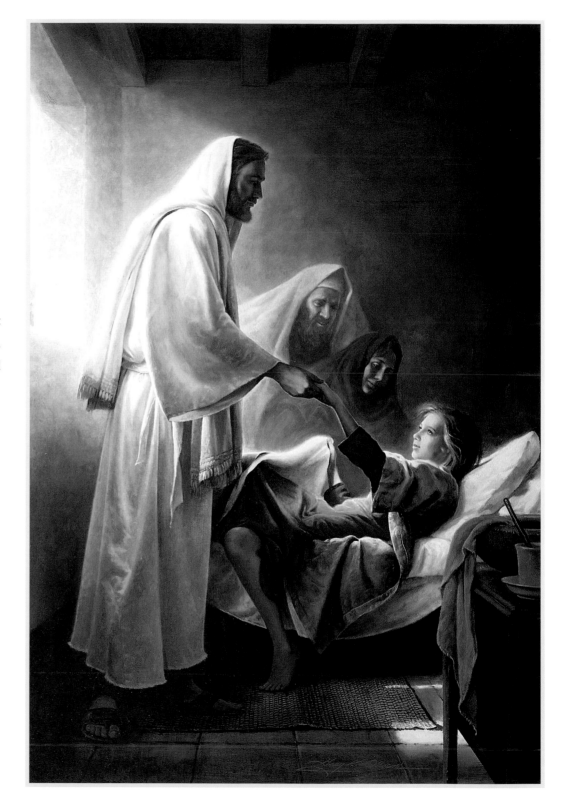

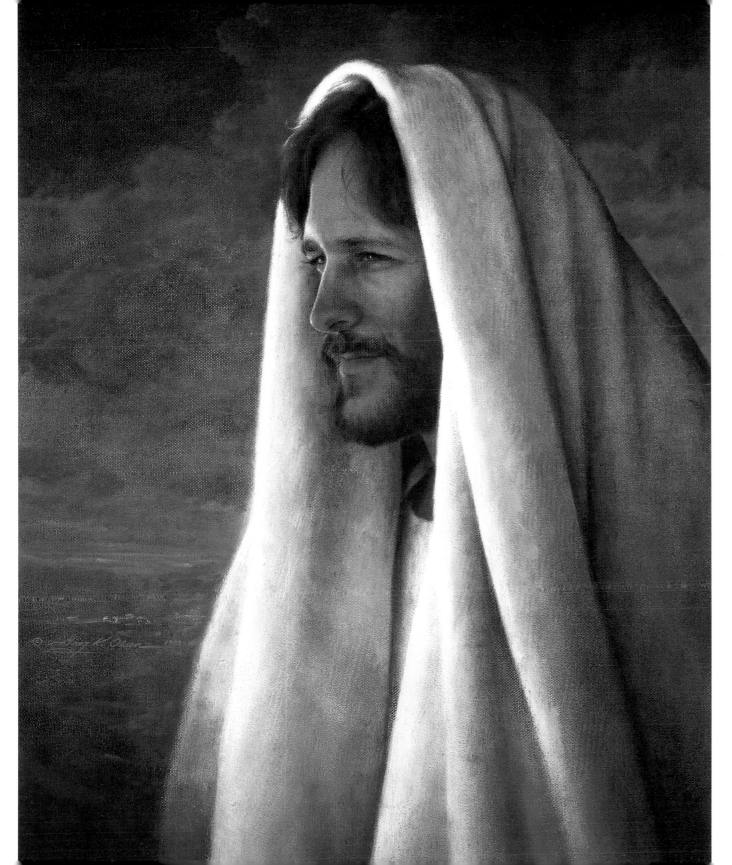

Gentle Healer

The idea of doing a painting which somehow claims to be a representation of the Savior Jesus Christ seems both presumptuous and impossible. At the very least it is intimidating. Each individual Christian probably has a very personal and unique image of Him in their mind, none of which an artist can duplicate or fully capture. My intent has been to paint images that I refer to as "symbols" of Him. They are an attempt to capture my feelings about Him and to reflect some aspect of His spirit and character. The intent of such a painting is to help us remember Him, and as we do, we invite His spirit to be with us.

— Greg Olsen —

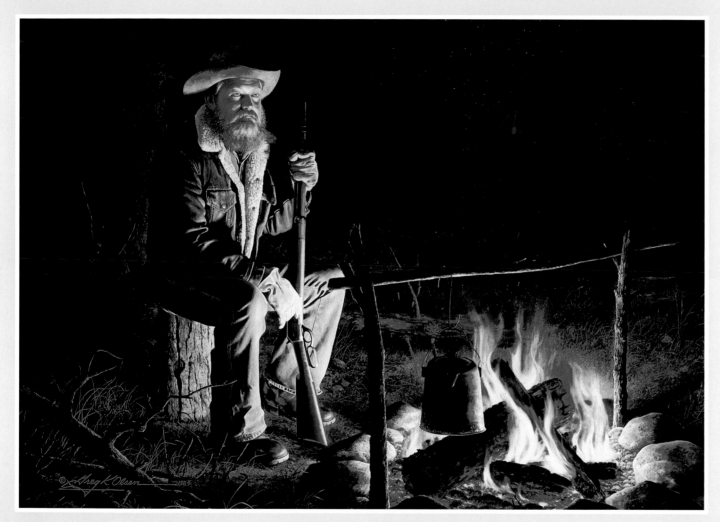

'NIGHT IN GRIZZLY COUNTRY

Out West

The characters of the West have always held a certain charm. With their fierce independence and individuality, they had what it took to tame a wild and challenging frontier. They were examples of ingenuity, self-sufficiency, and hardiness— characteristics we still hope to emulate.

— GREG OLSEN —

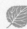

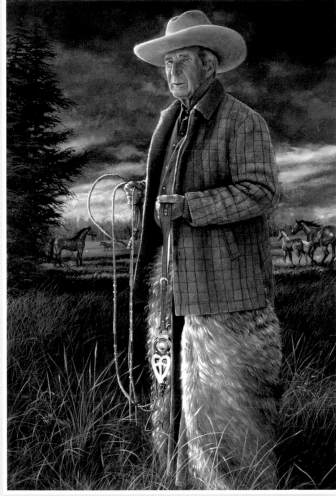

WOOLEY CHAPS

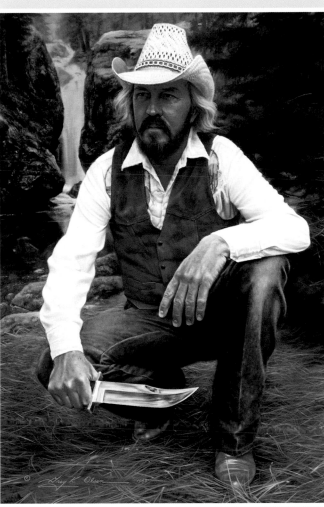

THE KNIFE MAKER

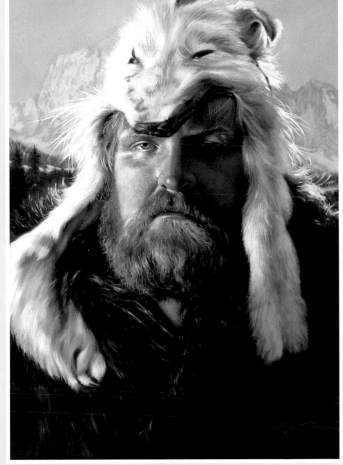

BIG ED

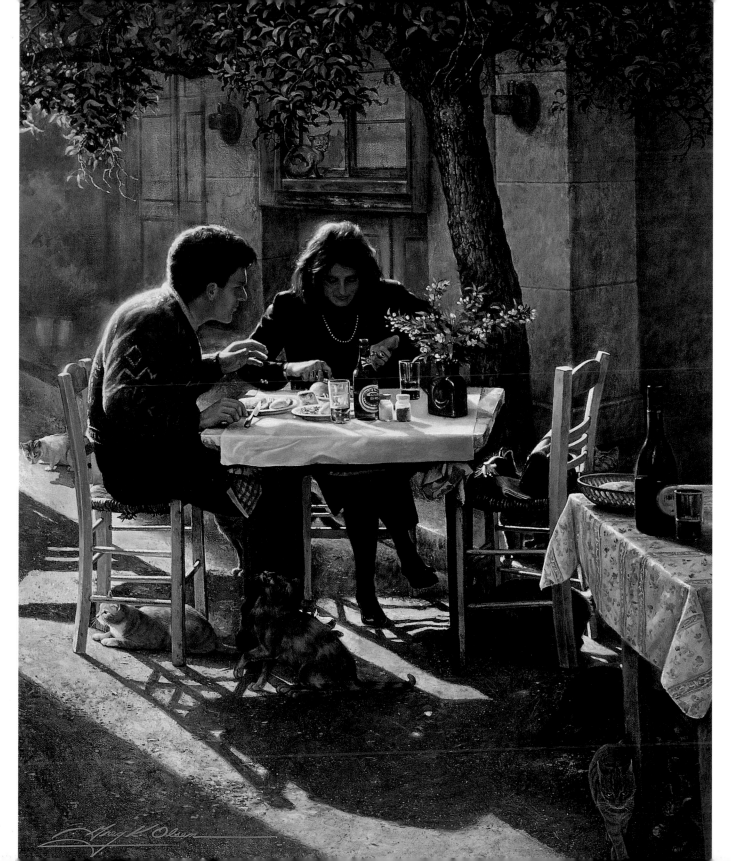

Company for Dinner

This couple, dining at a sidewalk cafe in Athens, Greece, probably hadn't counted on needing quite so many place settings for their dinner guests. (There are 17 cats in the painting.) These "hosts" were quite gracious in spite of the unannounced arrivals!

— GREG OLSEN —

June 4, 1944 — Rome, Italy

This painting was commissioned by the United States Pentagon. June 4, 1944 is the day the Allied Forces liberated the city of Rome during World War II. It is a tribute to all those who have served their country, and a reminder of the blessing and the price of freedom.

— GREG OLSEN —

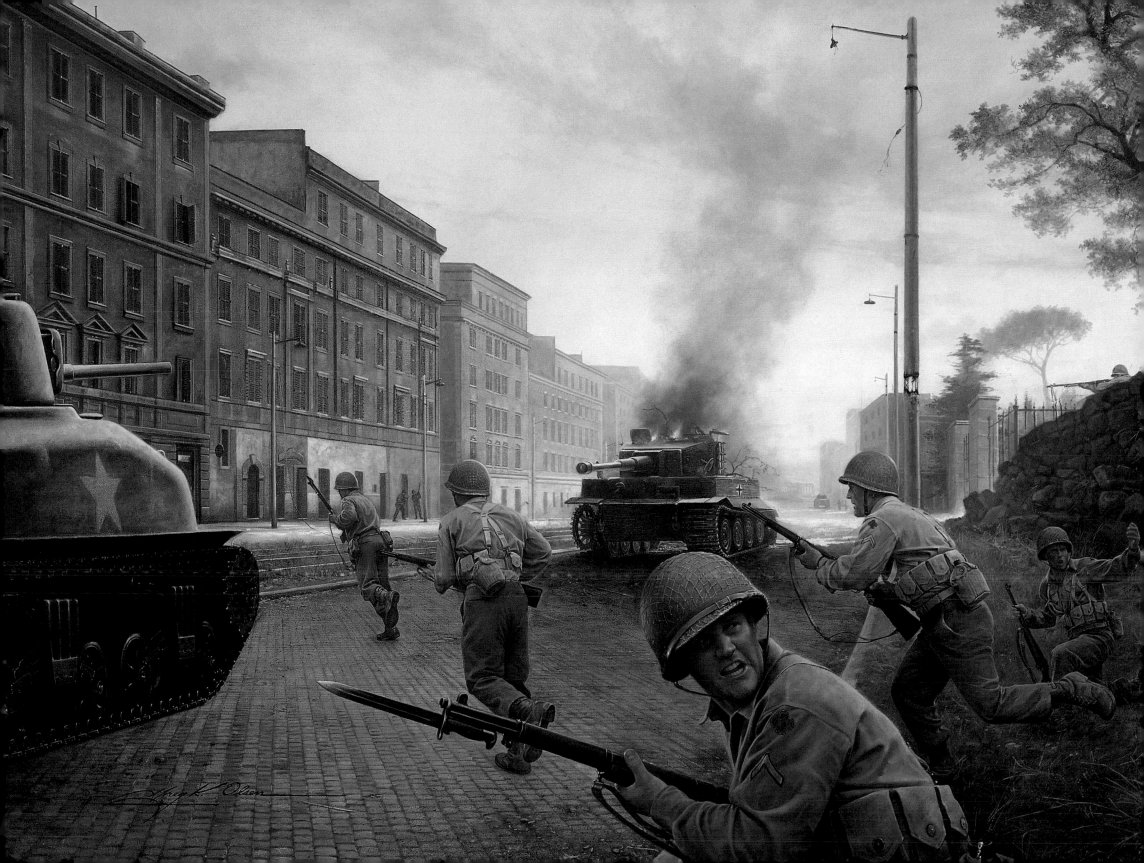

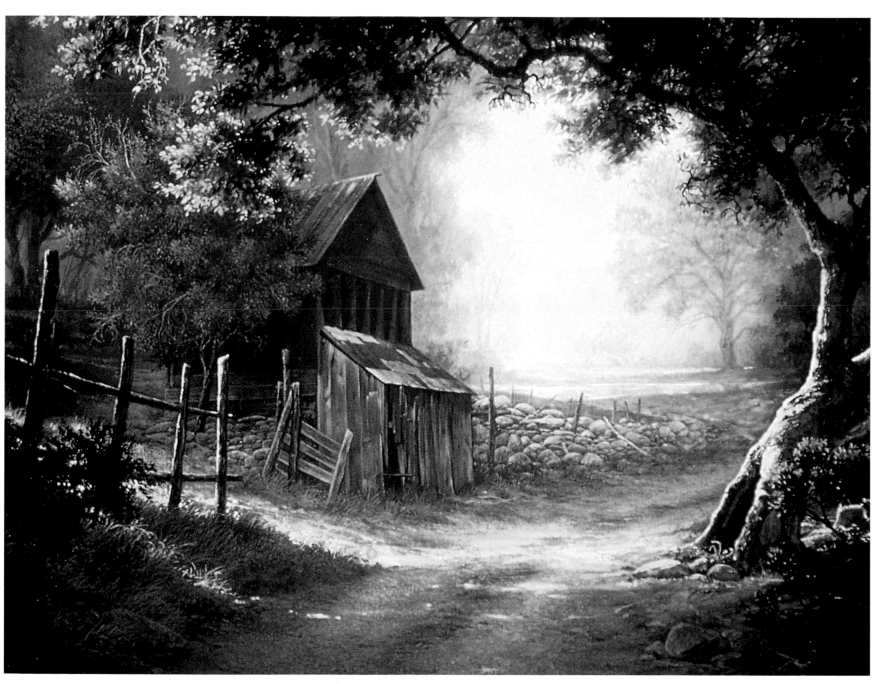

ABOVE: COUNTRY LANE. RIGHT: HOOK, LINE, AND SUMMER.

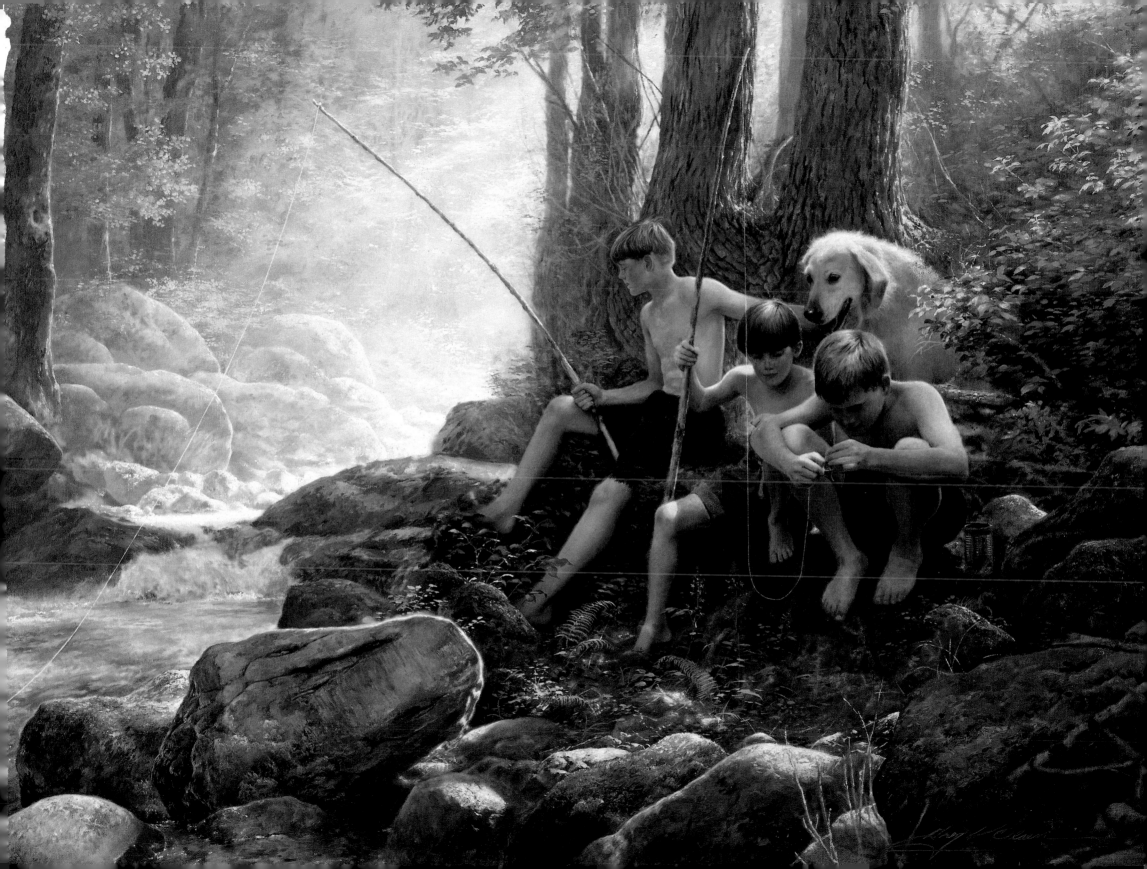

Harvest

The lessons of the harvest offer lessons for life. There is a need for one to clear the land and till the soil, to form the furrows and in the right season plant the seed. Just as vital is the role of one to tend and nurture the tender sprouts, to water and provide the necessary nutrients, to weed and determine when the crop is mature and ready to harvest. Our society functions on this same principle. Everyone has their own unique gifts, talents, and purpose which they contribute in creating the miracle of civilization.

— GREG OLSEN —

RIGHT: THE SOWER. OPPOSITE: THE HARVESTER.

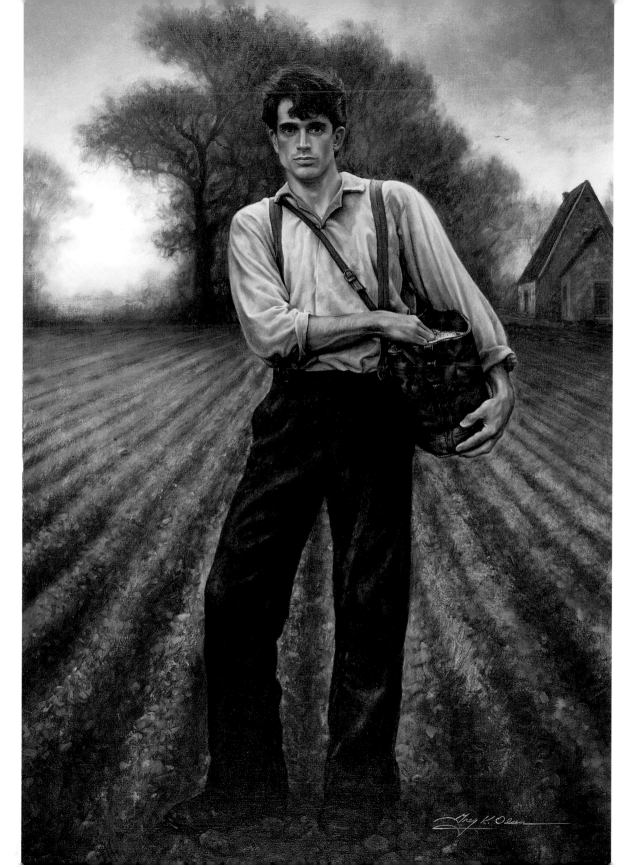

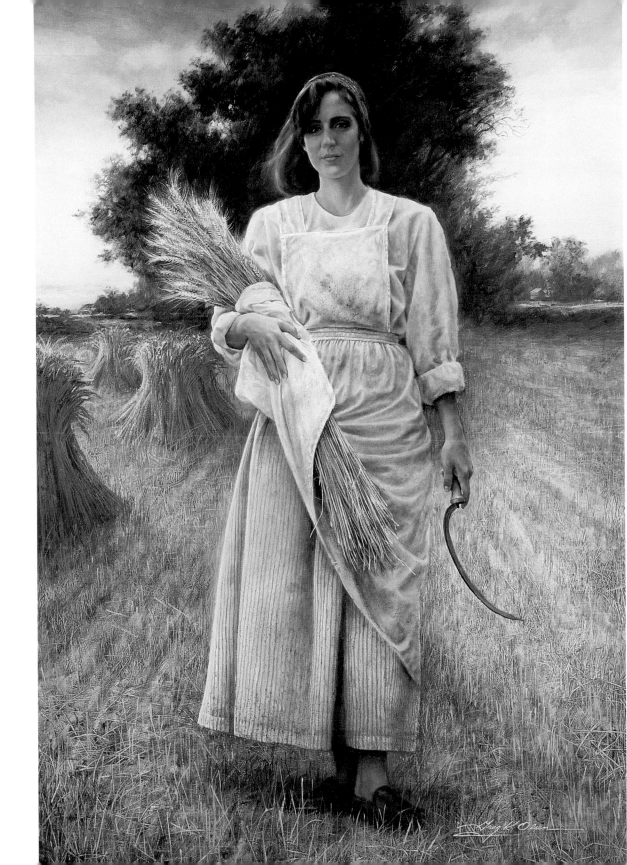

A Light to the Gentiles

The promise of a Savior was fulfilled by our Heavenly Father in Christ, who is the Light of the World.

— GREG OLSEN —

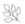

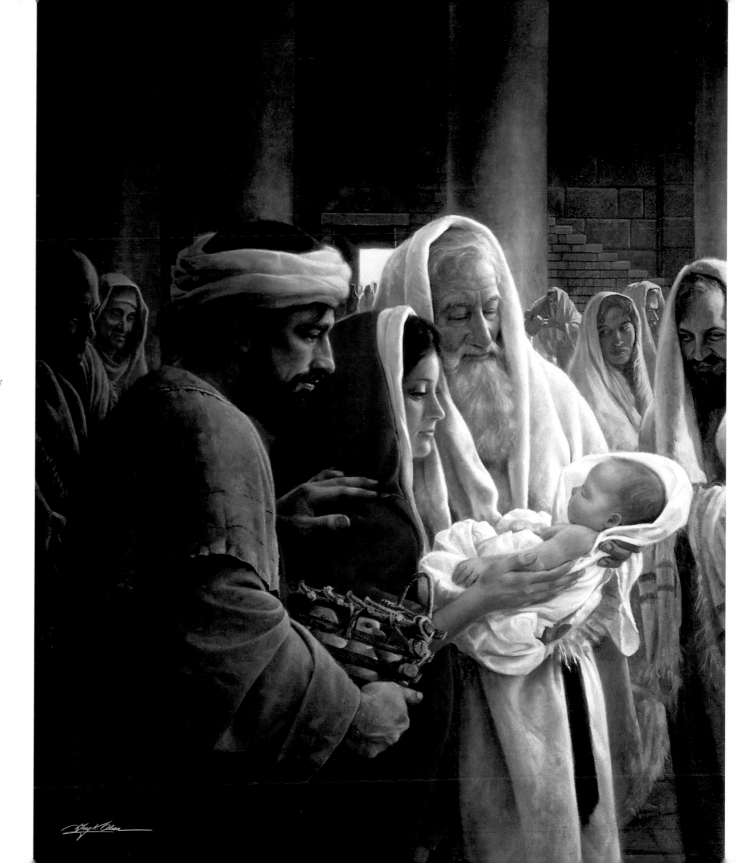

Prince of Peace

In a troubled world full of conflict and strife, the Master offered these comforting words, "Peace I leave with you, my peace I give unto you: not as the world giveth, give I unto you. Let not your heart be troubled, neither let it be afraid" (John 14:27).

The storms of turmoil may rage all around us, but inwardly, our hearts, minds, and spirits can be calm and peaceful. Through the eyes of the Prince of Peace we see a horizon beyond the clouds where the light of a new day begins to break forth.

— GREG OLSEN —

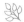

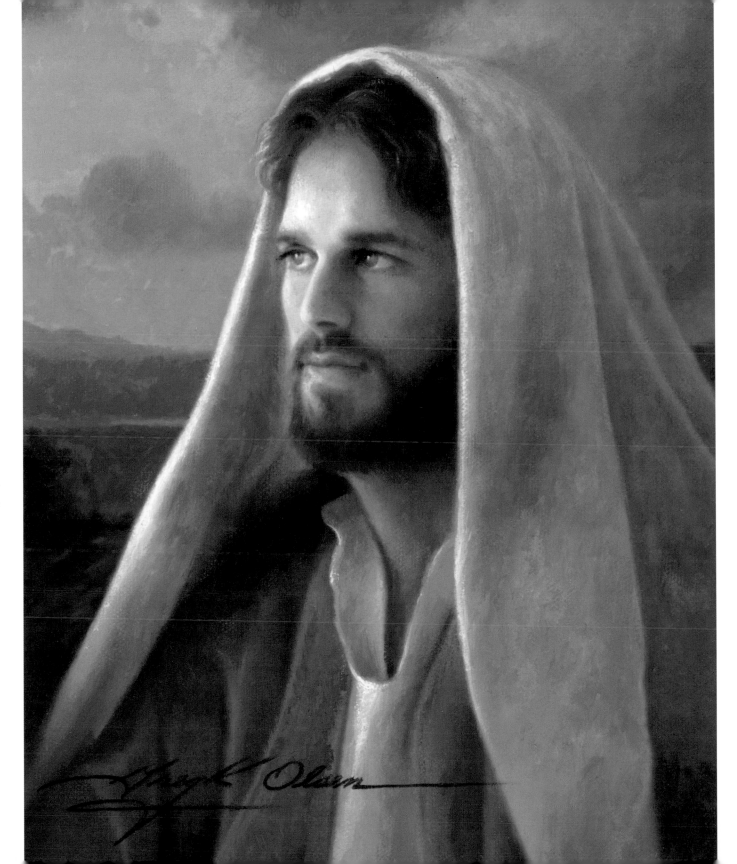

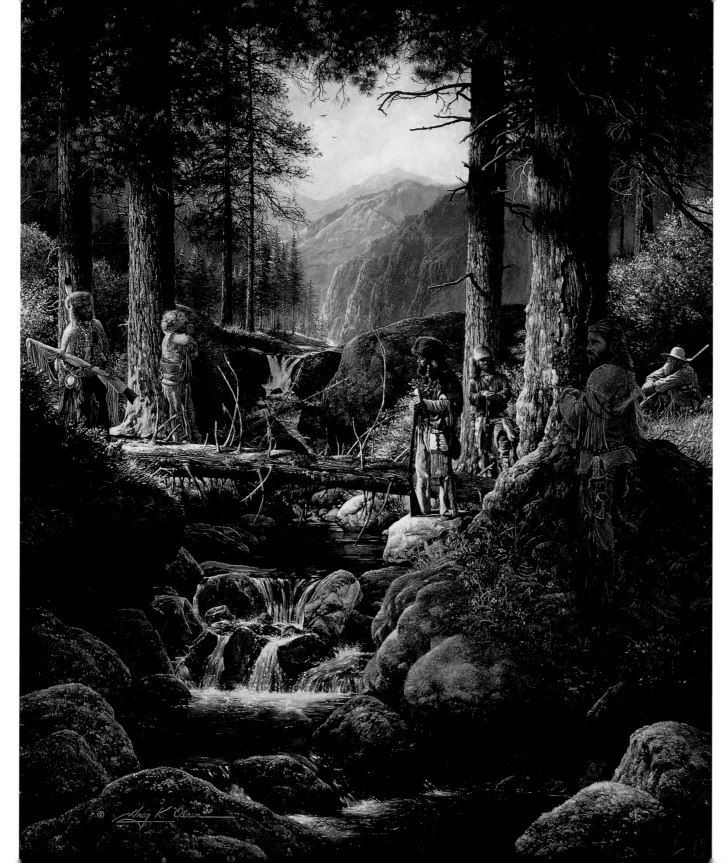

Nature's Tranquility

Nature offers an array of special places to which the frazzled soul can retreat and find tranquility and rest. There is something calming about water, whether it is lapping at a shoreline or spilling over the stones in a stream. Notice how the bubbling brook doesn't stop to worry about the many obstacles in its path; it simply flows over them or around them and continues on its way.

An observer would be hard-pressed to catch nature in an act of toil or worry. The Creator has provided for the needs of the plants and animals, and their beauty is evidence of that fact. Are we any less cared for? Nature reminds us that we are not, and her attitude is contagious if we slow down and take the time to soak it in.

— GREG OLSEN —

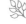

LEFT: NATURE BREAK. OPPOSITE: PADDLING STILL WATERS.

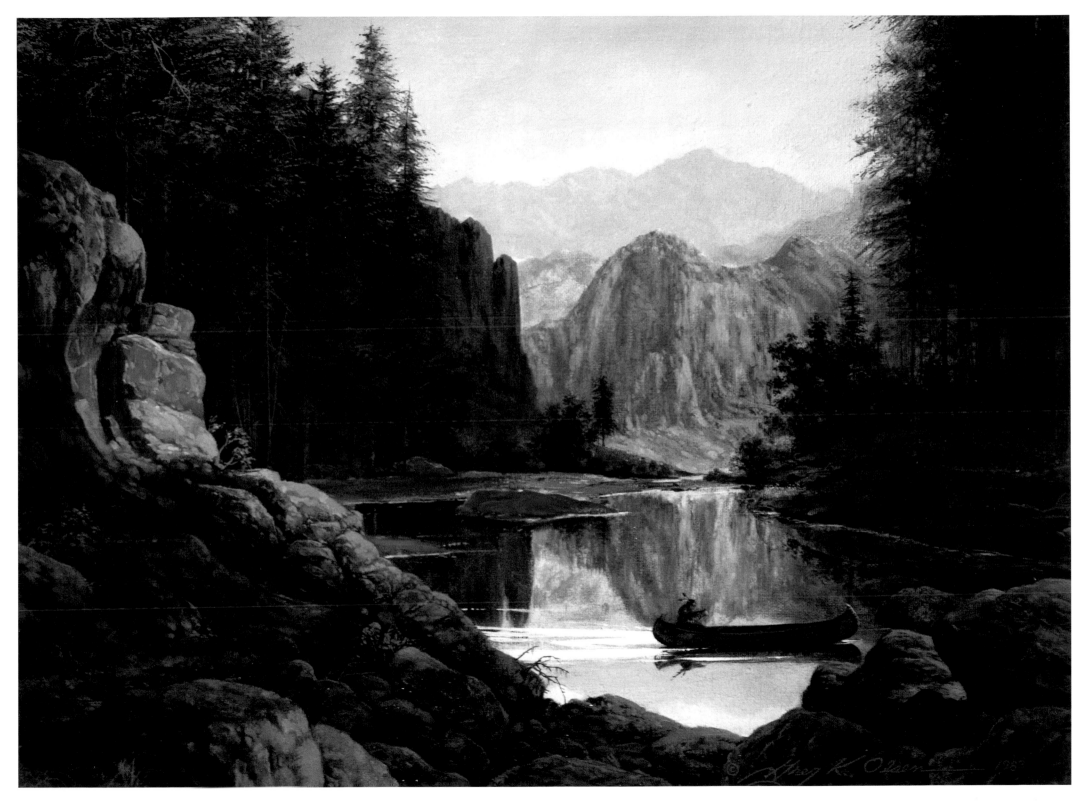

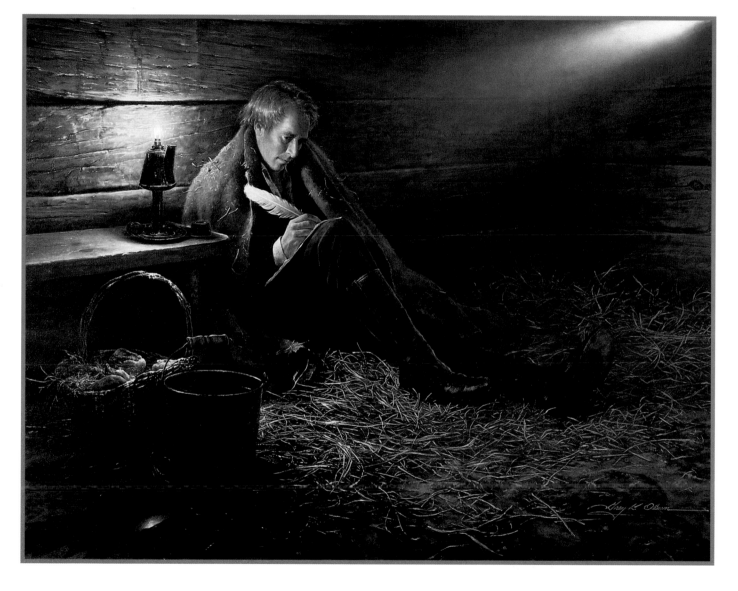

Joseph Smith in Liberty Jail

Trials and tribulations often bring some of our most profound insights and understanding. As Joseph was inspired to write during his trying ordeal in Liberty Jail, ". . . all these things shall give thee experience, and shall be for thy good." Sometimes "for our good" means something which serves the end desired. "Good" because it is for our experience even though not always for our comfort.

— GREG OLSEN —

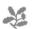

Job and His Family

Having passed through trial and tribulations, having lost all that he had, Job still praised the Lord for His goodness. In return, the Lord opened the windows of heaven and blessed the faithful Job many times over.

— GREG OLSEN —

Lehi's Dream

In *Lehi's Dream* I find a symbolic reminder of my search for that which is most important to me and my family—the tree of life. It represents the love of God and all He has to offer. All around us there are things that attract our attention, distracting us from the love which we most desire. As we hold onto the iron rod (the Word of God which is Christ), He will lead us to that love which fills our hearts with charity for ourselves and for all men. This charity, which is the "pure love of Christ," is our most prized possesion.

— GREG OLSEN —

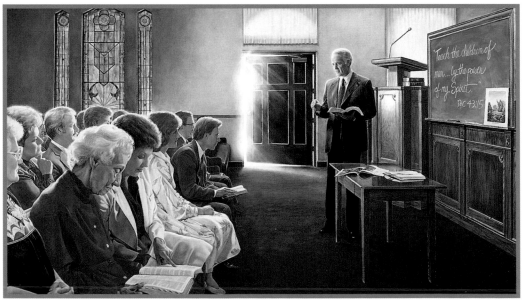

LEFT: LEHI'S DREAM. ABOVE: TEACH THE CHILDREN OF MEN BY THE POWER OF MY SPIRIT.

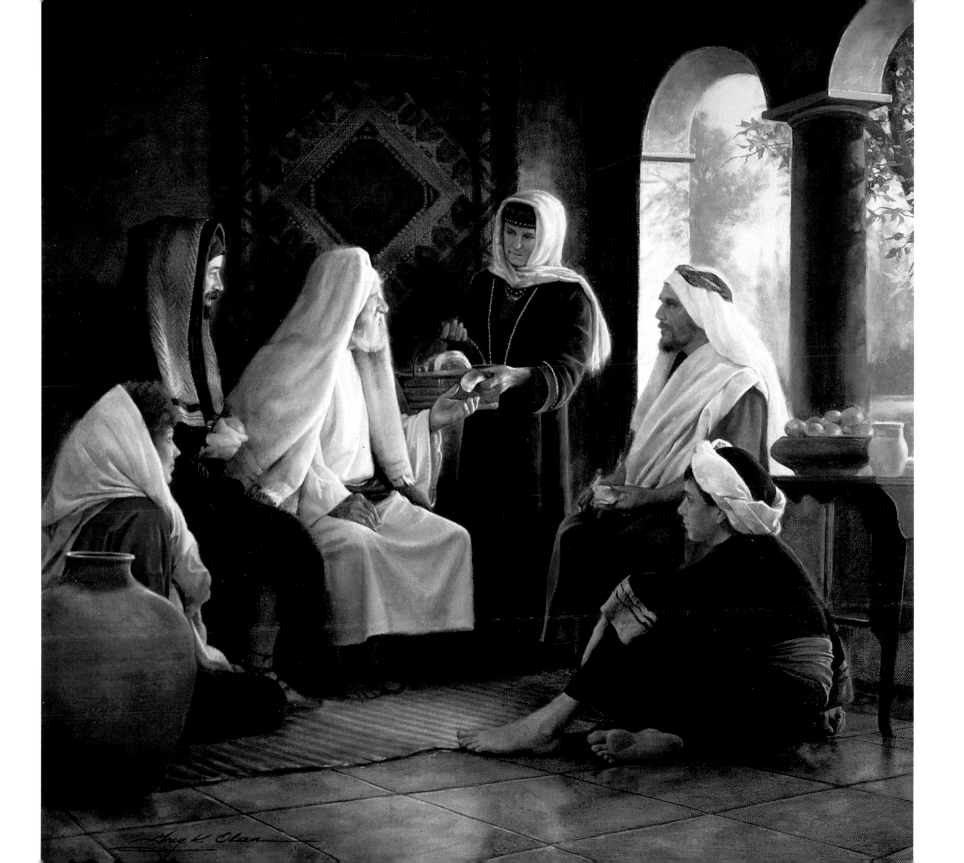

Concordance and Index

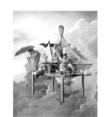
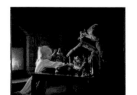

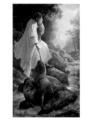
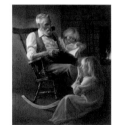
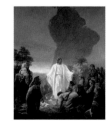
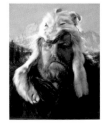
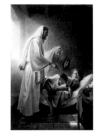
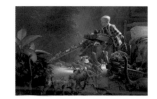
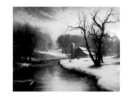
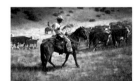
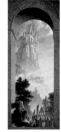
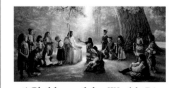
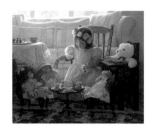
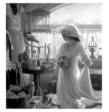
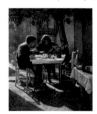
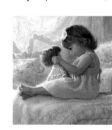
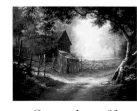

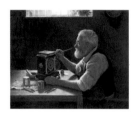
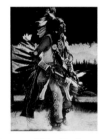
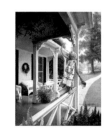
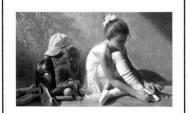
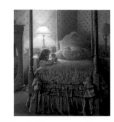
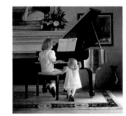
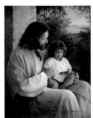
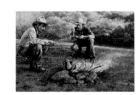
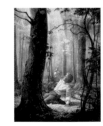
104

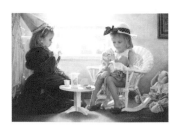
Formal Luncheon, 61

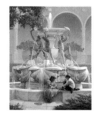
*Fountains of My Youth, 60

*Fraternity Tree, The, 56

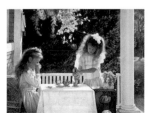
Front Porch Tea Party, 54

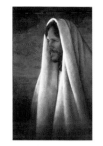
Gentle Healer, 87

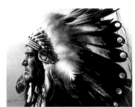
Great, Great Grandson of Geronimo, 71

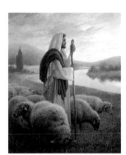
*Good Shepherd, The, 42

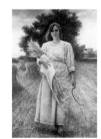
Harvester, The, 95

High Country Warefall, 1

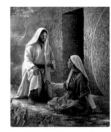
*He Is Risen, 9

Heaven Sent, 22

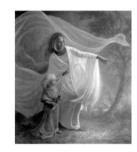
*Heavenly Hands, 38

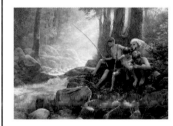
Hook, Line, and Summer, 93

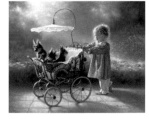
*I Love New Yorkies, 65

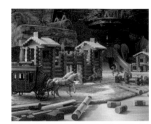
*Imagination: The Final Frontier, 30

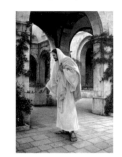
*In His Constant Care, 63

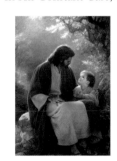
*In His Light, 53

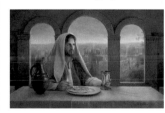
*In Remembrance of Me, 26

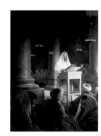
Jesus in the Synagogue at Nazareth, 8

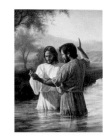
Jesus and John the Baptist, 8

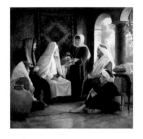
Job and His Family, 103

Joseph Smith in Liberty Jail, 102

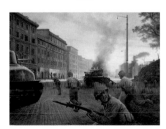
June 4, 1844 — Rome, Italy, 91

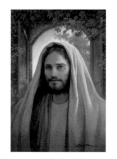
*Keeper of the Gate, 62

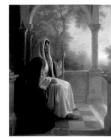
*King of Kings, 47

Knife Maker, The, 89

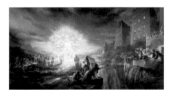
Lehi's Dream, 100

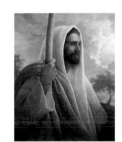
*Light of the World, 52

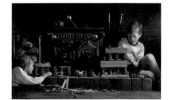
Lincoln Logs, 31

105

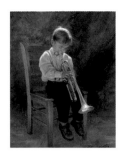
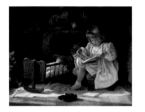
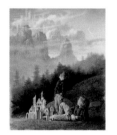
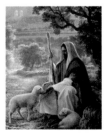
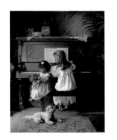
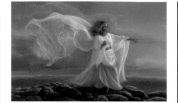

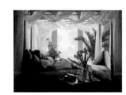
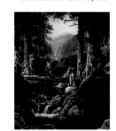

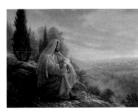
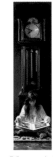
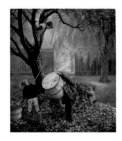
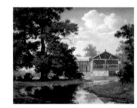
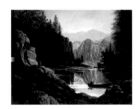
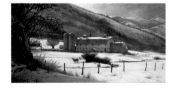
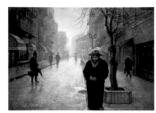
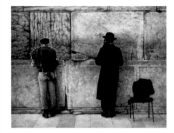
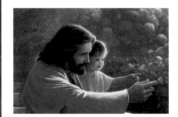

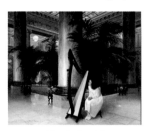

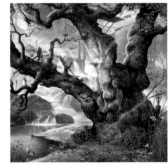
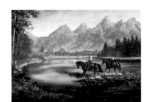
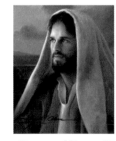
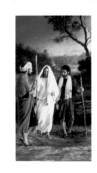
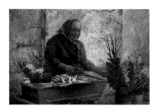
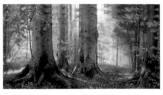
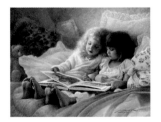

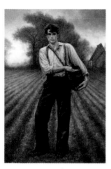

Sower, The, 94

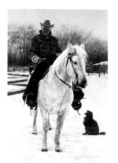

Tom Shurtliff, 51

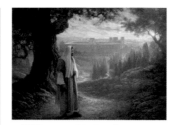

*Wherever He Leads Me, 46

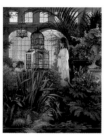

*Summerhouse, 15

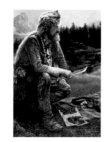

Trader at the Rendezvous, 48

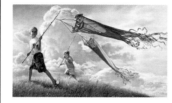

Wind Socks, 58

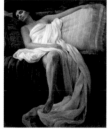

Sydnie, 83

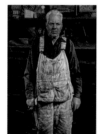

Tradesman, The, 69

*Winter Quarters, 40–41

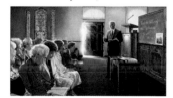

Teach the Spirit of Men by the
Power of My Spirit, 101

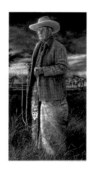

Traveling by Book, 6

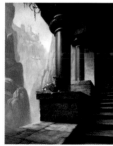

Wooley Chaps, 89

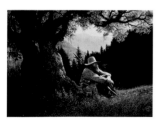

Thinking Tree, The, 80

* These images have been
printed as art prints. Please
visit your local book store, or
call Visions of Faith at
800-853-1352 for more
information.